Murders in Monmouth

Murders in Monmouth

Capital Crimes from the Jersey Shore's Past

George Joynson

Charleston London

History
PRESS

Published by The History Press
Charleston, SC 29403
www.historypress.net

Copyright © 2007 by George Joynson
All rights reserved

First published 2007

Manufactured in the United Kingdom

ISBN 978.1.59629.348.9

Library of Congress Cataloging-in-Publication Data

Joynson, George.
Murders in Monmouth : capital crimes from the Jersey Shore's past / George Joynson.
p. cm.
Includes index.
ISBN 978-1-59629-348-9 (alk. paper)
1. Murder--New Jersey--Monmouth County--History. I. Title.
HV6533.N3J69 2007
364.152'30974946--dc22
 2007031769

Contents

Introduction

A hundred years ago, sensationalism surrounded murder cases just like it does today. Newspaper reporters, like today's television camera operators, brought every scintillating detail to the public. In 1927, Mrs. Christina Stoble was on the front page of every local newspaper for days and weeks. Who would have thought the mother of ten children could murder one of her own? Reporters wrote about her crime, arrest and jail stay, her plea of not guilty and the trial itself—just like when the cameras captured every second of the O.J. Simpson murder case. Murder is a tragic event but people have always been fascinated by it. Who got murdered? Who did it? Where? Why? How?

Newspaper reporters rushed to the scene of the crime and wrote what they could. Getting their story in the next edition was more important than getting details correct. The newspaper accounts supplied a lot of information for these chapters but were surprisingly faulty. Official documents, scarce in some cases but plentiful in others, including court records, coroner inquests, death certificates and other governmental documents, also contained errors. Just because it's in black and white doesn't always mean it's true, or maybe back then there was just less concern about accuracy.

Murder has always been punishable by death in New Jersey. Edward Brown's execution in 1906 was the thirteenth, and last, legal hanging in Monmouth County. Brown was the 199th known execution in New Jersey. In 1906, explicit details of the minute-by-minute account of his hanging were front-page news. In this day and age those reports might have carried the following rating: Caution—Adult Material. Contains violent and graphic descriptions.

The first known legal execution in Monmouth County occurred in 1690, when the court ordered a black slave named Cesar to be hanged

for murdering Mary Wright. They hanged him in Shrewsbury. The last execution in New Jersey was 1963, when the state executed Ralph Hudson via electric chair for killing his wife. Hudson was the 361st execution. Currently there are ten convicts on death row in New Jersey, but there is a move to abolish the death penalty.

One of the 157 known murders between 1900 and 1930 was committed by Patsy Siciliano who shot and killed his brother-in-law in 1921. He was found not guilty in self-defense. *Photograph courtesy of Bud Benz of Artistic Photography.*

In New Jersey there is an exception to the Open Public Records Act (OPRA). Files of a criminal investigatory nature are closed to the public. Even if the case is closed and happened a hundred years ago and all the people are dead, it is still closed to the public. The county prosecutor, as well as several local police departments, did not respond to written requests for information.

Conversely, people in the Monmouth County Archives, the New Jersey Archives and the New Jersey State Police Museum were more than willing to share information. Their efforts and their service were proactive, cooperative and much appreciated.

These twelve murder cases, presented in chronological order, have two things in common. They took place in Monmouth County, and they occurred between 1900 and 1930. They were selected out of 157 known murders in the county during those years. Some other cases not covered in this book received much publicity, such as the murder of ten-year-old Marie Smith by Frank Heidemann, and later, the Mafia-ordered hit on Carmen Caizzo. In the early 1900s, there was a large community of Italian immigrants living in the west side of Asbury Park. By 1913, police dubbed it "The Battlegrounds," because there were so many assaults, murders and violent crimes in the area around Springwood Avenue.

The twelve cases that I have chosen represent different motives, ethnic groups, locations and relationships between victim and killer, as well as different outcomes. Researching them was exciting but writing about the tragic ones, especially where children were involved, was more somber. It is sad to imagine the pain that innocent children must have felt. Three generations later, there are some descendants that are still unable to talk about what happened to their ancestors eighty years ago. Their unwillingness to share their memories was a disturbing reminder of how humans can so deeply hurt each other.

In 2000, more than 600,000 people called pristine Monmouth County their home. For the same year, 6 people were murdered in the county, as compared to 289 murders in the state. Despite being the most densely populated state, the murder rate in New Jersey is slightly less than the national average. Of all developed countries, the United States has the highest murder rate at 5.5 murders per 100,000 people.

Monmouth includes twenty-seven miles of Atlantic coastline and is the northernmost part of the famous Jersey Shore. It always ranks high in "best places to live" surveys and it is close enough to commute to high-paying jobs in New York City. The Jersey Shore, where I spent my summers crabbing and sailing, is a great place to live. There are 3,142 counties in the United

States; Monmouth ranks forty-second in highest income per capita. It is one of the fastest growing counties in New Jersey. These murders are the dark side of Monmouth.

Doctor Thompson
Conspires to Commit Infanticide

At the turn of the twentieth century, Henry J. Fowler was a twenty-seven-year-old, successful civil engineer in Long Branch who designed and built carriages. Fowler worked with John W. Eyles, a carriage builder from Sea Bright. He had hazel eyes, dark hair, a fair complexion and was five feet, six inches tall. He had an American flag tattooed on his right hand and the initials H.J.F. on the front of his right arm. For some time Fowler had been separated from his wife, Adele "Addie" Fowler.

Toward the end of the summer of 1899, Fowler became friendly with the very pretty Miss Henrietta "Etta" White. She was twenty years old and the unwed daughter of the widowed Mrs. Nellie White. During this era, this area of Monmouth County was a popular resort of the rich and famous. The city of Long Branch was known as the "Hollywood of the East" on the Jersey Shore. Sometimes you would see a famous actor strolling along the boardwalk or Long Branch Pier. Seven U.S. Presidents chose to visit, staying in ornate Victorian inns along Ocean Avenue for their summer vacations.

In this age of strict moral and rigid social mores, Etta learned that she was pregnant. News of her pregnancy jolted Fowler. Not wanting this scar on his reputation, he enlisted the help of his acquaintance, Dr. Reuben P. Thompson, a thirty-five-year-old Sea Bright resident, to secretly get rid of the baby after its birth. Fowler agreed to give Thompson fifty dollars for his part in this atrocious act. Thompson agreed, and five weeks before the birth, Fowler and Thompson formulated their devious plan. Ironically, Dr. Thompson was the son of former Sheriff John I. Thompson of nearby Highlands.

Etta, and her mother too, did not want the family disgraced with the illegitimate birth of a baby, so sadly, the expectant mother and grandmother stood aside to let Fowler and Thompson proceed with their plan to quickly and quietly dispose of the baby.

DAY OF THE MURDER

On May 1, 1900, Etta gave birth to a son in her mother's modest house at 607 Martin Street in Long Branch. Dr. O.A. Clark assisted in the birth. Clark was unaware of any suspicious behavior. He agreed to lessen the family's shame by filing the birth certificate with question marks for the baby's name and father's name, age and occupation, but he had no idea of what was about to happen. After Clark left, Fowler moved his newborn son to another room where Dr. Thompson was waiting. Dr. Thompson placed a funnel in the baby's mouth and poured an unknown liquid down its throat. The baby died in a few minutes. Together they wrapped the body in a piece of old curtain that Fowler took from the carriage shop. Fowler took the package to the nearest bridge over the South Shrewsbury River, weighted it with a large stone and threw the bundled baby into the water. He sank to the bottom and remained there for two months.

After the murder, Fowler went back to work, and Dr. Thompson went back to practicing medicine, as if nothing had happened. Etta and Nellie told neighbors the baby went to a good family. Fowler, obviously feeling stressed by the situation, mentioned to two co-workers about getting into trouble. About mid-June, fearful of being caught, Fowler fled to Cockeyesville, Maryland, where he began using the alias Joe Eckert. Dr. Thompson stayed in Sea Bright and continued his practice.

This awful conspiracy finally fell apart on July 2. On that day, fifty-one-year-old John Vogelsang of Lippincott Avenue, Long Branch, was having poor luck crabbing off Little Silver Dock. Crabbing was a favorite pastime of Monmouth County residents and still is today. The clear blue waters of the Shrewsbury River in Long Branch had just the right amount of salinity preferred by the delicious Jersey blue claw crabs. Vogelsang left the dock to find a better place to catch his crabs. As he peered over the side of Middle Creek Bridge over South Shrewsbury River, he spotted the bundle. Constantly changing tides may have dislodged it, causing it to move from its original deep watery grave. Vogelsang used his crab net to scoop it out from under the bridge, then used the handle to poke open the package. Realizing he had discovered a male infant, Vogelsang drove to nearby Goose Neck Bridge and showed what he had found to his friend and the bridge tender, Charles W. Roswell. Roswell called Coroner John W. Flock.

CORONER'S INQUEST

Flock called Monmouth County Detective Charles Strong. Flock also called a coroner's inquest and impaneled a jury. The jurors were Foreman William

J. Smythe Jr., William F. West, J.H. Lupton, Christian Fesler, William A. Dennis and William H. Alexander. At the inquest, Vogelsang testified about his finding the baby boy.

Detective Strong started the investigation and learned that one of Fowler's co-workers, Joseph A. Poole, had overheard Fowler say that he gave a baby and fifty dollars to a man. His co-workers were also in possession of a letter from Fowler that was sent from Baltimore. They had written back saying the police were hot on his trail and not to return. Coroner Flock notified the Baltimore Police Department to be on the lookout.

In Baltimore, Captain A.J. Pumphrey and Detective Herman Pohler traced Fowler to Cockeysville, then to the village of Warren in Baltimore County. The detectives drove up to the cottage where he was staying and saw him peeping around the corner of the house and then quickly disappear. Inside, they found Fowler hiding between a door and a mattress. Pumphrey and Pohler cuffed "Joe Eckert," and brought him to the Baltimore Jail.

In custody, Fowler confessed to his true identity and implicated Dr. Thompson. The Baltimore detectives found Fowler's story so unbelievable— that a doctor would do such an awful act—that they suspected Dr. Thompson in Fowler's story to be a fictitious person.

Detectives back home in Monmouth County verified that indeed Dr. Thompson did exist. Detective Strong arrested Miss Etta White, Mrs. Nellie White, Harry Fowler and Dr. Thompson and charged all four with murder in the first degree.

THE TRIAL

The day before the trial was to begin in Monmouth County Courthouse in Freehold, both women agreed to provide state evidence in exchange for lighter sentences. Etta White made a full written confession. On January 2, 1901, Fowler and Thompson pleaded guilty to the lesser charge of murder in the second degree. Although the law allowed a sentence of thirty years, this was their first offense. Judge John Franklin Fort sentenced both men to eighteen years of hard labor in the New Jersey State Prison in Trenton.

White and her mother testified for the state and went free. Prosecutor John E. Foster agreed to drop all charges against the women. Foster felt there was not enough evidence of them committing the murder to warrant a guilty verdict. When notified of her complete acquittal, the young Etta White thanked the court and seemed much affected. She broke down in tears as she and her mother walked out of the courtroom as free women.

Judge John Franklin Fort sentenced Thompson and Fowler each to eighteen years at hard labor in New Jersey State Prison. *From the Collections of The New Jersey Historical Society, Newark, New Jersey.*

Fowler and Thompson were admitted to prison on January 16, 1901. It took nearly two weeks to arrange transportation to the prison because of the number of guards needed to supervise two prisoners. During the admittance process in Trenton, Fowler's personal property included fifty-seven cents. Dr. Thompson brought eight dollars and his clinical thermometer with him.

All prisoners admitted to the state prison, including Thompson and Fowler, signed this statement: "The Keeper of the New Jersey State Prison, or any Deputy he may appoint for the purpose, is hereby authorized to open and examine any Mail Matter which may be delivered at the Prison for me, and erase, or cut out, anything contrary to the rules therein contained."

PRISON YEARS

As her husband checked into the state prison, Fowler's wife, Addie, didn't wait long to dissolve her ties to him. On February 4, 1901, Addie, seven

Thompson signature. *Courtesy of New Jersey State Archives, Department of State.*

Fowler signature. *Courtesy of New Jersey State Archives, Department of State.*

months pregnant, filed for divorce in New Jersey Superior Court. She claimed her husband Harry wickedly disregarded the solemnity of his vows and committed adultery with Etta White. Addie received testimony from Etta, which she included in her petition for divorce. Etta explained that she was having immoral relations with Fowler and that she knew he was married. Etta told Judge J. Clarence Conover, "He said he was going to get a divorce from Mrs. Fowler and marry me." After Fowler moved out, Addie moved in with her mother, Mrs. Robert Crossett, in Eatontown. On April 30, 1901, Addie Crossett gave birth to Fowler's daughter, Myrtle Adeline (Fowler) Crossett.

Five and a half years later, on June 14, 1906, prisoner Harry Fowler made application to the Court of Pardons for clemency but his application was dismissed. The court granted him parole April 30, 1908, and a full pardon for his crime on April 16, 1913.

Dr. Thompson wasn't as lucky. After serving eight years of his eighteen-year sentence, the former physician petitioned the Court of Pardons for

a full pardon. The court granted him parole, but he refused. After legally being released, Thompson stayed in jail. On January 22, 1909, Thompson explained to the press that he could only be reinstated in the medical profession with a full pardon. He decided the food and conditions in jail were better than being on the street without the only way he knew to make his livelihood. This posed a problem for Warden George O. Osborne who said the state was not obligated to give Thompson free room and board. Thompson's sentence of eighteen years, less commuted time off for good behavior, would expire January 1914.

A few months later Warden Osborne's problem came to an abrupt end. On May 16, 1909, prison guards found Thompson dead in his cell. Coroner Frank K. Grove was not present but determined the cause of death was "a sudden hemorrhage of the lung." He was buried in Freehold. What really caused Thompson's sudden hemorrhage will remain a mystery.

Pop Caine Killed in an Argument over Sixty-five Cents

During the summer of 1902, George W. Lowden and Robert H. Caine worked together as waiters at the Avon Inn on Ocean Avenue in the quaint Victorian resort town, Avon-By-The-Sea. Joseph P. Hamblen of 261 Division Street, Brooklyn, owned the inn, and his brother, Arthur J. Hamblen, helped as manager.

George Lowden, born about 1867 in Virginia, had worked as a waiter for seventeen years in Newark, New Jersey, and had started working for the Avon Inn that summer. He was a quiet man, a little overweight, who never complained and always got his work done. Lowden had black hair and brown eyes.

Robert Caine was born in Pennsylvania before the Civil War and was older, about fifty-five or sixty years old, and taller in height. Caine had a wife, Eva, and twenty-three-year-old daughter, Jennie. "Pop" Caine, as he was called around the inn, was an equally industrious worker. Both waiters lived in the black workers' quarters provided at the inn, apart from their wives and family.

Earlier that summer, Head Waiter James C. Johnson had hired both men. When serving guests in the elegant dining room, the waiters wore a uniform of black pants, black vest, black tie, black shoes, and a shirtfront with a turned down collar. Over that they wore a tuxedo coat with a satin band and a waiter's apron.

Lowden signature. *Courtesy of New Jersey State Archives, Department of State.*

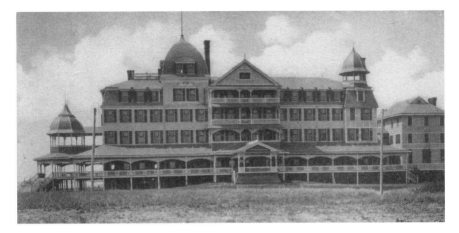

The grand oceanfront resort Avon Inn in 1902, where Lowden stabbed co-worker Pop Caine to death. *Courtesy of the author.*

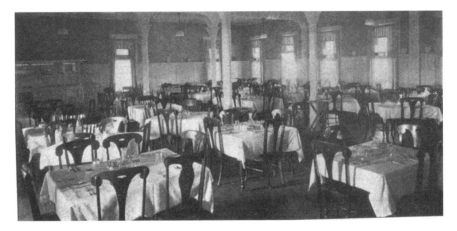

Waiters Pop Caine and George Lowden served patrons in the elegant Avon Inn dining room. *From* Images of America: Avon-By-The-Sea. *Courtesy of author Dolores M. Gensch.*

The Avon Inn, where Caine and Lowden worked, was originally built by Robert Batchelor in 1881. It was the first grand resort of the town. Batchelor purchased three hundred acres of prime oceanfront property for $45,000 in 1879 and developed the land. Forty-five thousand dollars in 1879 is about the same as $1 million in 2006. Since then, not much has changed in this sleepy town on one square mile along the Atlantic Coast.

In 1902 the basement of the inn was used to house the inn's workers. The rooms downstairs were dimly lit and were not often cleaned. The basement included two dining rooms, one for white workers and one for black workers.

There was also a porters' room, laundry room, pantry, waiters' room and ice room. The water closet for the black workers was out in the backyard.

The waiters' room held six cots, set about two feet apart. At the foot of each cot was space for one trunk, where each waiter kept his belongings. Waiters Solomon, Currie and Parsons slept there, along with Caine, whose cot was next to Lowden's. The two waiters worked together and slept side by side without problems, until the tragedy that occurred on the dark day of August 21, 1902.

That afternoon, Lowden reported to work as usual for the 1:00 p.m. lunch hour, but after about fifty minutes left work feeling ill. Lowden went downstairs to the waiters' room where he met Caine. He asked Caine to pay him the sixty-five cents he owed him so he could buy some whiskey. Sixty-five cents in 1902 had the same purchasing power as fifteen dollars would today. Caine said he would pay him later, but that wasn't good enough for Lowden. The two men argued. Their voices got louder and they insulted each other with ethnic slurs. Lowden then took a steel shaving razor and slashed Caine across his stomach, leaving poor Pop Caine with a deep, eleven-inch-long gaping wound. Caine and Lowden were the only ones in the waiters' room when the stabbing occurred.

Lowden put the bloody razor in a cigar box and headed out of the room. Nineteen-year-old Pantry Boy Harry Cordes and Porter Richard Thomas were sitting in the porters' room when they saw Lowden coming from the waiters' room. Cordes and Thomas saw Lowden with the cigar box in his hand and heard whatever was in it make a rattling noise. Lowden told Cordes to run upstairs and get Dr. Frank T. Hopkins. In passing, Lowden appeared to be very excited. He gave Thomas a sharp stare and continued on, walking rapidly and heading outside. Once outside, Lowden passed Gardener Joe Wright who saw Lowden cross the sandy road and head to the beach.

Around 2:30 p.m. that afternoon, Robert Campbell was taking in the sights and sounds in the pavilion at the beach. Campbell was a college student, residing at the Avon Inn for the summer. He watched Lowden cross the road and walk a short way onto the sand. Campbell watched Lowden as he looked around for a moment, took a couple of stomps in the sand and for about two seconds fussed around. It looked as if he was putting something in the sand. Lowden stood near the Berwick sign that read, "Lots For Sale." Once done fussing, Lowden returned toward the inn.

Meanwhile, the severely wounded Caine remarkably managed to walk outside. A few boys playing on the back lawn saw him and hollered, "A man was cut!" Second Cook Otto Pfifer heard the children, looked out his kitchen window and saw Caine walking from behind the bowling alley,

holding something in his hand against his stomach. Caine entered the basement at the white helps' dining room and laid down on the floor just inside the door. His intestines were hanging out and blood was running down his pants. Caine was dressed in his waiter's uniform. His apron and pants were saturated in blood.

Pfifer asked him, "What is the matter?"

Caine replied, "I am cut. I guess I am done for."

Shortly after he had lain down on the floor, Cordes arrived back downstairs with Avon Inn Proprietor Joe Hamblen and Dr. Frank T. Hopkins. Cordes held Caine's hand while Dr. Hopkins prepared to treat the wound. Hopkins called for some hot water and napkins, and told Cordes to go get Dr. Norris. Hopkins needed his instruments and assistance. Cordes ran upstairs again, rang the bell at the desk, and then returned to the downstairs dining room. The young Cordes must have liked and respected the elder Mr. Caine, as he compassionately stood by his side and held his hand while Dr. Norris prepared to administer the chloroform.

Before he went under, Caine made a statement which Manager Arthur Hamblen wrote down on the back of Dr. Hopkins's' prescription pad. This statement was witnessed by and the pad signed by Dr. Hopkins, Dr. Norris, the Hamblen brothers and Head Waiter Johnson. Hamblen wrote, "Lowden cut me. He wanted sixty-five cents for whiskey."

While waiting for help to arrive, Dr. Hopkins used a supply of table napkins from the dining room to keep Caine's intestines warm. Finally, with proper instruments, he reinserted the intestines into the wound then sewed the wound shut. By about 4:00 p.m., Caine was wrapped in bandages. Dr. Hopkins called for a carriage to get his patient to the Long Branch Hospital. A delay in its arrival forced them to wait until the five o'clock train to Long Branch. Hopkins sent word along with Caine that the operation was done in less than sterile conditions in a dimly lit room with not enough help. Given the circumstances of the emergency, it was the best care his patient could have received.

Dr. Harry E. Shaw, on staff at Long Branch Hospital, was there to take in Caine around 6:00 p.m. Thursday night. By the time Caine arrived he was in bad shape, suffering from shock, with a weak pulse and cold extremities.

On Friday morning, Long Branch Hospital staff member Dr. Edwin T. Field arrived and saw the note from Dr. Hopkins. Based on the unsanitary conditions that Hopkins was forced to operate under, Dr. Field decided to reopen and clean the incision. Before he went under ether a second time, Caine made another statement and Dr. Shaw wrote down what he said.

Dr. Edwin T. Field reopened Pop Caine's wound and found an Avon Inn table napkin wrapped around his intestines that was mistakenly left inside. *Courtesy of Monmouth County Historical Association Library & Archives.*

Lowden said, "When are you going to pay me?"
Caine replied to Lowden, "I'll pay you tonight."
Lowden said, "I'll cut you with a razor. I'll kill you if you don't pay me."
Then he slashed him open.

About 11:00 a.m., Dr. Shaw administered ether and Caine went out a second time. Dr. Field opened Caine's abdominal cavity and, to his surprise, found that a table napkin about eighteen square inches was still wrapped around his intestines. It had been left inside the wound. He saw indications of slight peritonitis, which may have been caused by dirt or foreign matter carried into the wound by the razor. Dr. Shaw removed the saturated napkin, cleaned the wound and restitched poor old Pop Caine once again. Caine lingered briefly before dying the next day, Saturday, August 22, 1902, about 11:00 a.m.

Coroner John W. Flock took charge of the remains and scheduled a coroner's inquest to begin August 23 at the Avon Town Hall on Main Street. Mrs. Caine, of 241 Sylvan Avenue, Asbury Park, came to the inn where Waiter William Sisco gave her the trunk that belonged to her husband,

containing his clothes, a brush and mirror. Proprietor Hamblen and several waiters were out of state residents, whom Prosecutor John E. Foster placed under bond to appear as witnesses when needed.

Back at the Avon Inn on the day of the attack, Lowden realized everyone was looking for him so he hid in the bushes. Manager Arthur Hamblen got his revolver and searched the helps' quarters. Hamblen called the Asbury Park Police to watch the trolley cars, as they might be able to catch Lowden escaping. It wasn't long before several women spotted Lowden behind some bushes. Clerk Austin Dutton came out, gave his revolver to Gardener Wright and told Lowden not to move. Dutton told Lowden he was under arrest. Wright held the gun pointed at Lowden while Dutton went and got Hamblen. When Hamblen arrived, Dutton and Wright took Lowden to the laundry room and locked him in; Dutton remained on one side of Lowden and Johnson was on his other side. Lowden wanted to leave to go to his room, but Dutton and Johnson insisted he stay put.

Soon Asbury Park Police Chief William H. Smith and Officer Edward Van Wickle arrived. Van Wickle handcuffed Lowden and moved him to the ice room—where the waiters filled the pitchers with ice water.

From there, Officer Van Wickle released Lowden into the custody of Neptune Chief of Police Walter H. Gravatt and Marshall James R. White, who re-cuffed Lowden and moved him to the porters' room. Chief Gravatt took charge of the prisoner because Avon had a local jail but not yet a local police force. The young town had only been incorporated since 1900. The new town was officially called Avon-By-The-Sea, but before that it was part of Neptune Township.

By now a large crowd was gathering outside. Gravatt and White walked the handcuffed Lowden out past the crowd and into the express wagon and took him to the Avon Jail. A search revealed that Lowden had $6.45 in his pocket and a pair of dice. By 4:00 p.m. the day of the attack, Lowden had seen his last moment of freedom.

Later that evening about 6:00 p.m., Robert Campbell overheard Avon Inn Night Clerk Rufus Vassar talking about that afternoon's attack. Campbell told Vassar that he had seen Lowden fussing in the sand and led Vassar to the spot. Vassar began to scuff the area, clearing away the sand. Two or three young boys and a lifeguard joined in the hunt. They looked for about ten minutes, until Vassar discovered the razor lying loose in the sand at the foot of the Berwick signpost. He stooped and picked it up. The razor was stamped, "Made By The United States Steel Co." Vassar handed it over to Arthur Hamblen, who handed it over to Chief Gravatt.

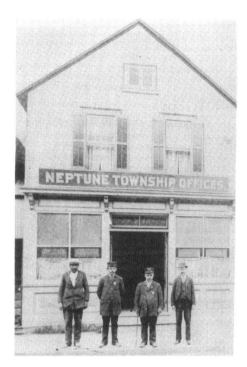

Police Chief Walter Gravatt, second from left, arrested Lowden at the Avon Inn. *Courtesy of Neptune Public Library Archive.*

Andrew Carnegie had just founded the United States Steel Company in 1901. At the time it was the largest business enterprise ever launched, with an authorized capitalization of $1.4 billion, or about $32 billion in today's terms. One of Carnegie's first items produced, the mere straight edge shaving razor, seemed insignificant to such a giant corporation, but was very much a vital part of the waiter's impeccable personal appearance. In this case, the shaving razor ended Caine's life as well as Lowden's freedom.

THE CORONER'S INQUEST

The coroner's inquest began August 25, 1902, at the inn. Coroner Flock impaneled a jury of six men: Foreman Joseph Frey, Cyrenius Waitt, John C. Embley, John L. Allstrom, Harry Woolley and James Griffin. Twenty-two witnesses were scheduled to testify. The list included ten workers who were there that day, three doctors who attended Caine, several police officers, guests and others. Due to the lengthy testimony, the inquest was continued at the inn a week later. After hearing all the testimony, the jury found that "Robert H. Caine met his death by being cut across the abdomen with a razor in the hands of George Lowden."

THE TRIAL

The *State of New Jersey vs. George W. Lowden* began November 13, 1902, at Monmouth County Courthouse in Freehold before Judge John Franklin Fort. Lowden pleaded not guilty. Prosecutor Foster presented the case for the state. Foster was able to get two written statements of Caine's words admitted as evidence. Counselor Samuel A. Patterson of Asbury Park, Counselor Cozzy of Newark and Counselor William T. Hoffman, an ex-judge, defended Lowden.

Lowden took the stand in his own defense. Lowden's version of what happened was very different than what Caine had said in his dying moments. Lowden said Caine admitted he owed him money and that the two argued about the money, but Lowden said Caine pulled a razor on him and tried to get him first. In the struggle, Lowden claimed, Caine accidentally stabbed himself.

After withstanding Prosecutor Foster's cross-examination, Lowden conferred with his counselors. Perhaps feeling the stress of guilt for killing Pop Caine, or that his chances of winning freedom were dwindling, Lowden had a change of heart. His attorney Hoffman stood and announced that his client wished to retract his plea and plead guilty to second-degree murder. Prosecutor Foster said that since the state's case was based solely on circumstantial evidence, he thought the court should accept Lowden's new plea. Defense Attorney Patterson pleaded for leniency for his client, but Judge Fort said he did not think the stab wound had been inflicted in self-defense nor was it accidental. Fort said he would announce Lowden's sentence December 3. Guards took Lowden back to jail to sit and wait until Judge Fort was ready to announce his decision.

On January 6, 1903, Judge Fort sentenced Lowden to twenty years in state prison at hard labor. Guards at the New Jersey State Prison in Trenton received Lowden on January 13 and assigned him prisoner number 334. At admitting, Lowden's personal property included just thirty cents and one plain gold band ring.

In June of 1911, prison guards transferred Lowden from the state prison to the state hospital. He died there on July 11, 1911, of general paralysis.

The Avon Inn continued serving guests until the 1970s. It suffered severe damage from fire in 1978 and was eventually torn down and replaced with summer resort houses.

The Brown Execution

"God have mercy on my soul."

Edward W. Brown was born in Richmond, Virginia, about 1870. In February 1903, Brown was in New York entering into a partnership with Edward A. Billups in the express business. Billups and Brown opened an office at 58 West Thirteenth Street. They hired Rebecca Traynum to work in the office, taking calls and keeping the books. When they needed help making deliveries, Traynum recommended her brother James. That September, Brown hired James Traynum. They worked hard as riggers, hoisting and carting goods for small businesses.

Eventually the relationship between Brown and Rebecca grew into more friendly terms. Despite being fourteen years younger than Brown, Rebecca moved into Brown's place at 113 West Twenty-eighth Street. She became known as Brown's wife. He was a very possessive man and did not allow Traynum to go anywhere other than work and home. Brown promised to marry Traynum but never kept his promise. The two quarreled and Brown became abusive. He threatened to harm her if she ever left him.

The abuse grew worse and continued until Traynum got up enough nerve to leave. She had tried leaving him on several occasions before but always returned. In May 1904, Traynum found a job as a servant and moved into her employer's house, but Brown found her. He threatened to hurt her and forced her to return to his place one more time.

As Billups and Brown tried to expand their business, employee James Traynum had an accident while driving a team of horses. In February 1904, the court entered a judgment of $272 for damages against the Billups and Brown partnership. The sheriff prepared to levy their assets. When Brown realized they were unable to pay, he decided he had enough—enough faltering business, enough New York City life and enough of Traynum trying to leave him.

With her brother's help, in early June Traynum moved out once again, this time to a friend's house in Long Branch. Traynum rented a room at 75 Belmont Avenue from friend Elizabeth "Lizzie" Jane Hall. She found work at Lillagore Pavilion on the beach in Ocean Grove. Once again, Brown somehow found out where she was staying.

Quickly and quietly Brown started dissolving his business partnership. On June 10, Brown called his partner and told him he had landed a big job and needed the truck and a team of horses overnight and would be back the day after. That was the last time Billups saw Brown or heard from him for the next two years. Brown sold the truck, the team of horses and other items, and he cashed several checks belonging to the partnership. With over $1,760 cash in hand, on June 11, 1904, Brown left New York. His final chore was to get Traynum. He had warned her not to leave again, and now, Brown would make certain she would never do so again. With his newly purchased revolver, Brown boarded the train to Long Branch, New Jersey, and headed to 75 Belmont Avenue.

Before going to Traynum's apartment the night of Saturday, June 11, Brown made a few stops at local businesses in Long Branch. He visited William H. Slocum's gentlemen's furnishings store, where he bought a dark gray golf cap with a button strap across the top. Next, Brown visited James H. Perkins' barbershop on Academy Alley, where he got a haircut and shaved off his mustache. Before leaving he asked permission to leave a package in his shop. Perkins approved. Brown walked the short distance over to Belmont Avenue, where he knocked at the front door of Mrs. R. Phillip's house. He asked if he was at 75 Belmont Avenue and Phillips told him 75 Belmont was right next door. Traynum was not yet home from shopping.

THE MURDER

That Saturday afternoon, Rebecca Traynum went looking to buy a pair of shoes. She returned late and ate dinner with Lizzie Hall. After dinner Hall retired, but Traynum stayed up late to finish some ironing in the kitchen. About ten o'clock, Lizzie awoke, startled by Traynum's cries for help, "Miss Hall! Miss Hall!" Traynum's helpless cries were followed by three pistol shots fired in rapid succession. When Hall got to the kitchen, the killer was gone. Traynum lay dead on the kitchen floor in a pool of blood with bullet holes in her head and her heart.

Brown ran out the back door, across the porch and into the yard. Mrs. Phillips heard the gunshots and heard his footsteps on the porch as he made his hasty getaway. Brown tossed the gun away and ran. When last

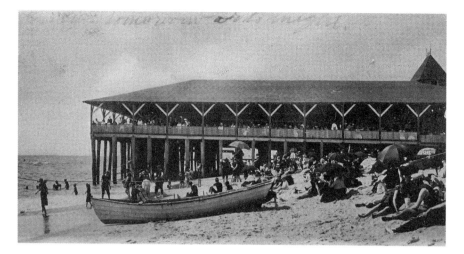

Victim Rebecca Traynum worked at the popular seaside Lillagore Pavilion in Ocean Grove. *Courtesy of Monmouth County Historical Association Library & Archives.*

seen boarding a train out of New York, Brown wore a black coat and vest, checkered pants and his new gray golf cap. Edward Bron fled to Chicago, where in a few days, he purchased a restaurant, coal and wood business from Edgar Smith. Conveniently, Brown assumed Smith's name and identity. In this manner, Edward Brown escaped justice for nearly two years.

Back at the scene of the crime, Phillips ran in to see Hall hovering over the dead body of Rebecca Traynum. The two women made enough commotion to stir the attention of tenant George W. Jimlson. Jimlson entered the house, saw Traynum dead on the floor and called police. Officers Fox and Brown quickly arrived at the scene. Officers William Walling and Miller arrived soon after that. Captain James Layton took charge. He sent a telegram to James Traynum in New York saying his sister was shot. Layton took statements from Hall, Phillips and Jimlson. Police found a man's glove in the kitchen. Coroners Flock and Hyer took the body to their morgue on Broadway.

The next morning, tenant John Bishop found the murder weapon nearby. Bishop saw the revolver as he was walking across the old Cooper property, between the old icehouse and the bottling plant. The gun was a five-chamber, .38-caliber revolver of cheap metal containing three empty cartridges. Bishop turned the gun over to Captain Layton. With this discovery, Layton was able to trace the escape route the murderer took. Layton established that Brown left the scene of the crime through the back porch, crossed over the adjoining yard and came out unsuspectingly onto

Belmont Avenue along the side of Cooper's barn. From there he made his escape.

James Traynum arrived the next day. He told police that Brown had disappeared a week ago. Traynum described his employer Edward Brown as having dark skin, about five feet, nine inches tall and bow-legged. When Traynum last saw Brown he was wearing light pants, a dark, blue-striped coat, a vest and a flat top derby hat. Traynum identified the glove found at the scene of the crime as belonging to his employer, Edward Brown.

Traynum told Layton that Brown and his sister did not have a good relationship.

> *He didn't treat my sister well and she left him five weeks ago. Brown discovered her whereabouts and insisted upon her returning to him. She refused, feeling safe in having me near at hand to protect her. She came to Long Branch with a view of getting away from him.*
>
> *Last summer, Brown followed my sister to Asbury Park and by threats and annoyances, forced her to go back to New York with him. Brown made threats against me, accusing me of separating him and my sister. He said he would kill me.*

Word of the murder spread through the town that Sunday. On Monday, Perkins opened the package that Brown had left. It contained a flat top derby hat. In the hat he found a business card from Brown & Billups. It also contained a three-inch by five-inch savings account book from Siegel-Cooper of New York. Perkins turned the items over to Captain Layton, who firmly established Brown's presence in the town on the day the crime was committed.

THE CORONER'S INQUEST

Coroner Queeney impaneled a jury June 12, 1904. The jurors were Judge Henry Schoenlein, William Hayes, Washington M. Wilson, Isaac Woolley, William Reihl and Washington Harvey. The jury viewed the body and visited the scene of the crime. Dr. John W. Bennett, who performed the autopsy with the assistance of Dr. Joseph T. Welsh, testified before the jury. Dr. Bennett showed the location of the bullets. One bullet had penetrated her skull and lodged in the brain; the other pierced her heart. Either would have proved fatal. Police told of finding a third bullet embedded in the floor.

Monmouth County Detective Elwood Minugh rode by rail to Chicago and returned with prisoner Edward Brown. Minugh worked on many murder cases. *Courtesy of Minugh's grandson, Edward Sinker.*

THE HUNT FOR THE KILLER

With all the evidence, Captain Layton began the hunt for suspected murderer Edward Brown. Layton telephoned Brown's description to police headquarters in Newark, Elizabeth, Jersey City, Brooklyn and New York. A reporter from the *Red Bank Register* wrote Brown's description as "a dark, coffee colored Negro, about 35-years old, weighs about 170 pounds, high cheek bones and high forehead, quite bow-legged, with two scars on the back of his neck caused by boils and cleanshaven."

Two years passed without a trace of Edward Brown. Police knew who they were looking for and had the evidence to convict him. They just couldn't find him.

Finally, in April 1906, Monmouth County Prosecutor's Office got a call from an unnamed detective of the Chicago Police Department. Prosecutor Henry Nevius had posted a one hundred dollar reward for the capture of Edward Brown. The Chicago officer had Edward Brown under surveillance and wanted to negotiate a bigger reward before arresting him.

On April 18, the Chicago police officer arrested Edward Brown. The officer thought that Brown might skip town so he decided to forego dickering for a higher reward.

On April 19, when Prosecutor Nevius received word that Brown had been arrested, he sent Monmouth County Detectives Elwood Minugh and Jacob B. Rue to Chicago. Brown admitted his true identity but declared his

innocence. He signed a waiver to allow extradition, which meant Minugh and Rue did not have to seek permission from Illinois Governor Charles S. Deneen to remove him from the state.

On April 20, Minugh and Rue escorted their prisoner back to New Jersey, and by 10:00 p.m. on April 21, Brown had been locked up in the county jail in Freehold.

THE TRIAL

On May 1, 1906, Edward W. Brown pleaded not guilty to shooting Rebecca Traynum. Judge Charles E. Hendrickson appointed John S. Applegate Jr., former Judge William Hoffman, Samuel A. Patterson and Thomas P. Fay as counsel for Brown, but all asked to be excused as there seemed to be no doubt of the man's guilt. Trial was set to begin May 21. Monmouth County Prosecutor Henry "Harry" Nevius represented the state and Attorney Edward W. Arrowsmith finally accepted counsel for defense. Brown maintained his innocence.

On May 22, Edward Brown took the stand in his own defense, testifying that he had never been in Long Branch and did not know that Traynum was there until after he read in the papers that she had been shot. He said he moved to Chicago for business opportunities. Brown said he used Smith's name because it was convenient. Brown had an answer for everything. He knew he was wanted in Long Branch, "but thought that was over with."

Brown explained that he met Rebecca in 1903 and the couple began living together in New York City that October. The two parted in May 1904, he said, as good friends.

Witness for the prosecution, James Traynum, said Brown and his sister Rebecca had a troubled relationship and he had heard them argue on several occasions. Traynum said he heard Brown threaten to kill her if she left him.

THE VERDICT

On May 23, 1906, after deliberating for about an hour, the jury returned a verdict of guilty of murder in the first degree without recommendation of sentence. That put the life or death decision into the hands of Judge Hendrickson. On May 28, Judge Hendrickson sentenced Brown to death, to take place Friday, June 29 between the hours of 10:00 a.m. and 2:00 p.m. The New Jersey Legislature had recently enacted a law allowing

Above left: Judge Charles Elvin Hendrickson sentenced Edward Brown to death. *Special Collections and University Archives, Rutgers University Libraries.*

Above right: Monmouth County Prosecutor Henry "Harry" Nevius presented the state's evidence in *State vs. Brown. Courtesy of Monmouth County Historical Association Library & Archives.*

electrocution as a means of execution, but funds to construct such a chair were not yet in place. That meant Brown was to die by hanging.

BAPTISM

During the days prior to the hanging, two clergymen, Reverend John R. Brown of the Mount Zion Baptist Church of Newark and Reverend J.A. Jordan of the Second Baptist Church of Freehold, regularly visited Brown.

The day before the hanging, Brown converted to the Baptist faith and asked to be baptized. Brown became very religious and asked Jailer John H. Fitzgerald to refuse interviews with newspaper reporters. His time left on earth was too short to waste. He spent most of his days in prayer.

For the first time since he was sentenced to die, guards unlocked his cell door and allowed Brown to exit his cell unshackled. He was dressed only in an old pair of overalls and a shirt. He stepped into the large bathtub, and while Reverend Brown read the service, Reverend Jordan pushed him backward until he was entirely submerged. Brown was then led back to his

cell and the sacrament was administered, the bread and wine being passed to him through the bars of his cell.

On Friday morning, June 29, after a brief session of prayer and a few minutes before the scheduled execution, Brown rose from his knees and said he desired to own up to everything. He related the circumstances attending the shooting of the Traynum woman and said he was sorry that he had done it and expressed hope that his death penalty would serve as a lesson to those who permitted their tempers to get the better of them. Brown confessed his crime to the two clergymen. He admitted that he had seen Traynum with another man, and in a jealous rage, followed her to Long Branch, and shot her.

THE EXECUTION

Edward Brown was put to death on the scaffold in the Monmouth County Jail in Freehold a few minutes later. Brown had said that he would not make any scene but would walk bravely to the gallows and he kept his word. About twenty-five persons, including Sheriff Seymour Francis, some jurors, doctors, jail officers and newspaper reporters witnessed the execution.

Officials hired Mr. James Van Hise of Newark, a professional hangman, to take charge of the hanging and paid him $500 for the job. Van Hise's nineteen-year-old son Walter assisted. When a hanging apparatus works correctly, death occurs quickly from a broken neck caused by the weight of the body and the distance of the freefall. If Van Hise set it up properly, the rope would not tear Brown's head off, nor would he slowly strangle to death.

Shortly before ten o'clock, Van Hise and the guards entered Brown's cell and adjusted the noose to fit his neck. His arms were strapped behind him and, accompanied by his religious advisers, the officers led Brown to the gallows. He had to turn two corners to reach the corridor where the gallows had been erected, and he walked past the witnesses as unconcerned as if he were going to leave the jail for a stroll. He nodded to all present and said "good morning" several times. Just before he took his place under the dangling rope he murmured his last words, "God have mercy on my soul." Brown wore a black suit and a black tie.

Not a word was spoken by the condemned man after he reached the gallows. They placed a black cap over his head. The hang rope was snapped fast to the noose, and in the next instant Brown's body shot into the air. It was 10:18 a.m. His body was raised from the jail floor by means of four round iron weights weighing five hundred pounds, which Van Hise released

Former Sheriff Obadiah Davis witnessed the last execution by hanging in Monmouth County, New Jersey, on June 29, 1906. *Courtesy of Monmouth County Historical Association Library & Archives.*

with a lever. The weights fell noiselessly into a box of sand. The murderer's head almost touched the cross beam of the gallows when the weights fell. When the body dropped to the end of the rope it was drawn and shaken by a series of convulsions. Severe convulsive movements of his lower limbs lasted about five seconds.

At one point one of Brown's hands clutched hold of the iron railing on the second tier of the corridor, but the grip soon relaxed. Physicians said that Brown was unconscious of everything and that he had no knowledge of the fact that his hand touched the railing. The convulsions became less and less severe and the last sign of life visible to the witnesses was a slight twitching of the man's hands. With the noose tight around his neck after the weights landed in the sand box, Brown's feet were about four feet off the floor.

At 10:20 Brown's body was still; at 10:22 the attending physicians felt his pulse and announced it was beating strongly; at 10:27 they felt his pulse

feeble but his heart was still beating; at 10:30 there was no heartbeat; and at 10:33 they pronounced Brown dead.

Fifteen minutes after the weights fell, Dr. Edwin T. Field of Red Bank, Dr. D. McLean Forman of Freehold and Dr. James J. Reed of Sea Bright pronounced Brown dead. They allowed his body to hang about ten minutes more, then guards lowered it into a plain black coffin. The rope had caused a slight abrasion on the skin of the left side of the man's neck, but otherwise there was no evidence that Brown had met with a violent death. The official cause of death was strangulation.

The guards placed Brown's body in the coffin then screwed the lid down. One of the clergymen conducted a short burial service. It was an impressive moment as the reverend uttered The Lord's Prayer. All stood with bowed heads. At the conclusion, the undertaker, George B. Freeman of Freehold, took the body and drove away.

Those witnessing the execution included former Sheriff O.C. Bogardus, former Sheriff Obadiah E. Davis, W.E. MacDonald, W.A. Sweeney, George J. Taylor, Henry J. Bodine, Dr. John W. Bennett, Dr. Harry E. Shaw, Dr. Harry Neafie, Dr. Andrew Jackson, Attorney Andrew J.C. Stokes, Samuel Kirkbride, E.I. Vanderveer, Seymour Francis, Walter S. Reed, William Walling, Alonzo Bower, George A. Longstreet and David Buck.

Members of the press there included E.P. Thompson, Charles E. Close and Stenographer Arthur W. Kelley. Also witnessing the execution were Reverends John R. Brown and J.A. Jordan.

Brown's 1906 execution was the last by hanging in Monmouth County.

Triple Murder at Sheppard's Squab Farm in Wickatunk

In the spring of 1908, Frank Zastera lived with his parents, Anton and Anna, two brothers and three sisters at 347 East Seventy-second Street in New York City. Frank was the second eldest at twenty-one-years-old. He was born in Austria but had lived in the United States since he was five years old. He liked to draw and play the violin. Frank's father was a wealthy engineer.

After being bit by a dog, Zastera's father noticed something not quite right about his son. Anton brought Frank to a doctor, who told the young man that working on a farm would be good for him. Zastera checked the newspapers and found a Catholic placement agency in Brooklyn. He called Father Thomas Blake of St. Vincent's School for Boys on Atlantic Avenue and State Street in Brooklyn. Through Father Blake, Zastera met William B. Sheppard. Sheppard agreed to hire Zastera to work on his squab farm in Wickatunk. On May 15, Sheppard brought Zastera to the remote farmlands of Monmouth County and introduced his new farmhand to his wife Josephine.

William B. Sheppard was a veteran of the Spanish-American War of 1898. When the war broke out he enlisted, and with Company M, served as lieutenant in the Seventy-first Regiment of New York. He saw active service in the Battle of San Juan Hill.

After the war, Sheppard went back to New York City and worked for an insurance company. He married Josephine Ryan, daughter of John Ryan of 201 Eighteenth Street in Brooklyn, in October of 1903. Sheppard visited an old acquaintance, Mr. J.C. Punderford, of Matawan, New Jersey, and liked the area of Monmouth County. He met with financier William Sesso of Philadelphia, who agreed to purchase some land and help him set up a farm. On November 3, 1905, Sesso purchased the old ninety-five-acre Garrett Wall estate near Wickatunk. Sheppard and his wife moved out of the city and onto the Wickatunk farm. With Sesso's backing, Sheppard constructed outbuildings to raise pigeons and squabs.

Frank Zastera posed for *Matawan Journal* newspaper photographer after being arrested for triple murder. *Courtesy of Matawan-Aberdeen Library.*

In June 1907, Josephine gave birth to their daughter, Marie Sesso Sheppard. Sheppard hired young Jennie Bendy, seventeen years old, of Matawan to help his wife with the household chores. Bendy's father Edward lived in the nearby Freneau section of Matawan. By May of 1908, Sheppard was making a good living for his family. He had about four thousand pigeons and a regular income from his weekly sale of squabs.

A squab is a young pigeon before it learns to fly. At twenty-five to thirty days old, a squab reaches its maximum degree of plumpness. The meat is rich, dark, tender and moist. Today it is considered a gourmet dish at specialty restaurants.

To help with the workload, Sheppard hired Huron Voifrum, a Hungarian immigrant who did not speak much English, to help care for the pigeons. Sheppard also hired Bendy's sister to help Huron learn English but Huron was surly and disrespectful. Mrs. Sheppard also noticed Huron being cross to the baby. About ten days before the murders, Sheppard dismissed him. Sheppard went back to St. Vincent's and asked for another farmhand and that is when he met Frank Zastera.

Less than two days on the job, Zastera decided he had enough. The work was too hard and the pay was too little. Zastera decided to do something drastic. Unfortunately, his mind didn't differentiate between right and wrong.

NIGHT OF THE MURDERS

In the early morning hours of May 16, 1908, Zastera entered the Sheppard's white two-story farmhouse. Sheppard was a marksman and had a large collection of firearms, including a Krag-Jorgensen rifle and a Winchester rifle. Over the past months, thieves had raided his stock several times. Sheppard intended to scare them away and kept ready his loaded Winchester rifle, a repeating shotgun, on a hallway rack near the entrance. Sheppard had shown Zastera how to use the Winchester to shoot crows and taught him how to handle the pump that threw the dead shells out.

Zastera grabbed Sheppard's Winchester rifle off the rack and hid in the parlor. As Mrs. Sheppard headed back up the stairs with a bottle of milk for the baby, Zastera fired two loads of buckshot, tearing away her hip and left side. Mr. Sheppard heard the shots and came running, but as Zastera put it, "I was afraid he would get to me and tear me to pieces, so as he came down the stairs I let him have the shells. He tumbled down the stairs and landed near his wife's body. Then I ran around to the kitchen and shot Jennie because I was afraid she would tell." Zastera shot everyone in the house except for eleven-month-old Marie, asleep in her crib at the foot of her mother's empty bed.

With no one left alive to stop him, Zastera ransacked the house. Sheppard's pockets were turned inside out. Zastera ripped open mattresses and broke drawer locks. He rifled through bedroom closets and drawers. He rummaged through storage tins, five pocketbooks and a few boxes. He did not touch the wedding rings on the fingers of the bloody bodies. After looting the entire house, Zastera ran to the neighbors and told them someone shot the Sheppards. He said he was in the stable tending the cow at the time. The neighbors notified county detectives. Word of the crime spread rapidly. Neighbor Henry Hayes took the suddenly orphaned child into his home. The *New York Times* reported that Sheppard's sister, Miss Helen Sheppard, arrived in Wickatunk the next day. As she left town to board the train back to New York, Helen took her baby niece, Marie, and her belongings to her home in Brooklyn.

SEARCH FOR THE KILLER

Wickatunk was, and still is, a section of Marlboro, which didn't have its own local police force until 1962. Marlboro Township's population was less than two thousand people in 1908. The local sheriff and constables serviced the area. On this particular case, Monmouth County Assistant Prosecutor

Andrew J.C. Stokes led the investigation. Stokes notified Sheppard's parents in Brooklyn. He notified local police and New York Police and made arrangements to borrow William Bennett's bloodhounds. Bennett brought his dogs in from Atlantic Highlands to scour the countryside for clues to the murderer's identity.

Nearly one hundred neighboring farmers and their families joined in the search. Lieutenant Sheppard and his wife were well respected around Wickatunk. As an *Asbury Park Press* reporter told it, "The whole countryside is awake over the outrage." Stokes feared a mob lynching and tried to keep it out of the newspapers.

Stokes's first suspect was the recently fired farmhand Huron. Authorities contacted other police departments in search of Huron.

ZASTERA'S CONFESSION

When interviewing Zastera, Stokes began to notice some peculiar statements in his answers. The first tip to arouse his suspicion was that Zastera said he did not hear any of the five shots. The cow barn was not more than two hundred feet from the house, and Zastera admitted that the windows in the house were open as was the barn door. Stokes, along with Detective S.S. Cosgrove of the Drummond Agency, Monmouth County Detective Charles C. Strong and Warden Edward Cashion started to suspect Zastera instead of the previously fired farmhand. They took Zastera to Freehold and began intense questioning, taking turns interrogating him. Zastera said he had nothing to do with it. Then he said he couldn't remember what happened. Hours passed; Zastera was denied food and sleep. Stokes brought in bloody clothing taken from the Sheppards but Zastera did not flinch. Detective Cosgrove made him put on Sheppard's bloody vest, the blood hardly dry. Stolidly, he denied everything. Cosgrove brought in a Bible, opened it randomly, and told Zastera to put his hand on it and swear that he did not do it.

That's when Zastera began to break. Cosgrove noticed some blood from the clothing had gotten on his hand and had marked a verse in the Bible. "There's blood on that verse," he said to Zastera, "and do you know what the verse is?"

Cosgrove read it to him. It was the one hundred and ninth verse of the One Hundred and Nineteenth Psalm, which reads, "My soul is continually in my hand; yet I do not forget thy law."

"That applies to what I have told you about your soul," said Cosgrove. Then Zastera read the passage for himself.

Cosgrove asked him sharply, "Weren't you in the parlor when Mrs. Sheppard came downstairs?"

"Yes, I was," said Zastera.

"And you killed her?" asked Cosgrove.

Zastera answered with barely a whisper, "Yes."

Finally, after ten hours of questioning, Zastera confessed. With his hand on the Bible, Zastera finally said, "I did it." Zastera said that he was underpaid. He wrote and signed a confession witnessed by Edward Cashion:

> *I came in with the milk, set pails down in front of refrigerator and then went into the house and got the gun from corner where Mr. Sheppard had set it the night before; then into the parlor and concealed myself near the hall door; and in a few minutes Mrs. Sheppard came down with milk bottle in left hand and went toward the kitchen and came back in short time with milk bottle and went toward stairs and I shot her three times. I again see Mr. Sheppard at head of stairs. He stooped and started downstairs. I shot and he fell on the banister. Then I shot again and he fell over on his wife's body. I then went out toward the kitchen and saw Jennie and shot her. I then went back to where Mr. Sheppard's body was and took pocketbook from his hip pocket and took out the bills but left the check. I then put the pocketbook in his pocket and went upstairs and put the gun in the corner of the small room and then came downstairs and ran out the side shed door and dropped the money next to the woodpile. I then went to notify Mr. Wall.*

Zastera said he knew Sheppard kept a large sum of money in a big leather purse he carried on the inside of his coat pocket. "I wanted the money. It came to me all at once to kill him and his wife that morning when I got up to milk the cow." Zastera said he buried all the money he found under a locust tree.

Sheriff Asa Francis, Detective Strong, Prosecutor Stokes and Detective Cosgrove went out to the Sheppard farm to look for the buried money. Several local farmers joined in the search. They dug and dug, but after upturning hundreds of cubic yards of earth, nothing was uncovered. The next day at four o'clock in the morning, they brought Zastera back to the farm to show them where to dig. Once at the Wickatunk farm, Zastera said he simply couldn't remember where he hid the money. He was back in jail by seven o'clock that morning. Detectives guarded the property and continued to search for the hidden money but never found it.

On Monday, May 18, 1908, Detective Strong officially charged Zastera with triple murder of the Sheppards and Bendy. Judge James E. White sent

him to jail without bail. Judge Willard P. Voorhees granted application of a grand jury to meet in extraordinary session. In custody, Zastera posed for newspaper photographers, who put his picture on front pages of leading newspapers throughout the state of New Jersey.

Zastera's father Anton came from New York and met with his son that weekend. He hired former Judge William T. Hoffman and Attorney Samuel A. Patterson to defend his son. Zastera's father began talking to his son in their native Hungarian language, but Detective Cosgrove stopped him. Cosgrove warned him that if he tried to speak in any language other than English the interview would terminate immediately.

Zastera's father told the press, "My boy is innocent. Frank was bit by a dog a year ago and since then his mind has weakened by the thought that he had hydrophobia. He was treated at Pasteur Institute. He is weak-minded and has been so for a long time." While Zastera was in jail, his father paid Warden Cashion to provide his son with regular table fare. He brought his son his violin so he could play while he waited for the trial. After meeting with his father, Zastera denied confessing and said he had nothing to do with the murders.

CORONER'S INQUEST

Coroner John R. Cravatt held an inquest in the Monmouth County Courthouse in Freehold on June 6. Cravatt impaneled a jury of twelve men: Foreman Charles E. Conover, Joseph E. Miller, Charles R. Storm, W.S. Stryker, Michael King, C. Schanck Herbert, H.P. Hayward, William S. Hyers, Horatio Whaley, Gideon C. McDowell, Marcellus Quackenbush and William Schenck.

Seven witnesses gave testimony, including William Wall, a neighboring farmer who lived adjacent to the Sheppard property. Dr. James D. Ely, who witnessed the scene of the crime, gave testimony as to the position of the bodies and the wounds. Neighbor Frank McDowell who lived not quite a mile away, testified that he heard the shots. Neighbor Charles Story also testified.

Prosecutor Stokes brought Zastera's signed confession and submitted it as evidence. Stokes said that when he arrived, Mr. Charles E. Conover had already found the Winchester rifle propped against a wall in a room upstairs. Stokes found one shell in the gun and five empty shells scattered about in the dining room, parlor and kitchen area. One shell was sitting on the cushion of a Morris chair in the parlor. Stokes said at the scene of the crime he found a check for eighty-six dollars in Sheppard's pocketbook, which he turned over to the Sheppard heirs.

Zastera's father sat and listened but did not take part in the inquest.

After hearing all the testimony, the jury found a verdict that fixed responsibility where it was due. Their verdict read," We do find that the said William B. Sheppard, Josephine Sheppard, and Jennie Bendy came to their deaths on the sixteenth day of May 1908 by gunshot wounds at the hands of Frank Zastera."

The Trial

Assistant Prosecutor Andrew J.C. Stokes represented the state's case. The first thing defense attorneys Hoffman and Patterson did was to pronounce their outrage with the treatment detectives afforded their client. Their aim was to exclude the confession. Hoffman told the press that Zastera endured eighteen hours of nonstop questioning. During that time they denied him food and sleep. Hoffman stated:

> It was an outrage upon civilization. I have never heard of a man being subjected to such treatment as Zastera received during my legal experience. What did the results amount to anyway? All that the honored Assistant Prosecutor obtained from the young man is a confession of guilt, which had not been corroborated in any particular, and upon which an intelligent, fair man will not base a decision, in view of the boy's weak mind. He withstood the horrible ordeal of the "third degree" for many hours, and then went out of his head, confessing his gut. He was crazy when he made the confession. He was sane when he withstood the "third degree" and gave a clear cut account of his actions.

Detectives had charged Zastera with three separate counts of murder; he was facing electrocution if a jury found him guilty of any one offense. Defense attorney Hoffman claimed that the bite from the dog led to Zastera's insanity, and asked that his client's mental condition be examined.

On July 31, at the request of the defense, Judge Willard P. Voorhees postponed the trial until September. Hoffman and Patterson were having difficulties getting out of state witnesses to come to New Jersey and take the stand in Zastera's defense.

Without going to trial, Judge Voorhees committed Zastera to the New Jersey State Hospital for the insane in Trenton. On September 20, Judge Voorhees listened to the testimony of three doctors who examined Zastera. Voorhees said that when Zastera was restored to his right mind, he should be returned to Freehold and placed on trial for charges of murdering his three victims.

Dr. William H. Hicks of Newark, considered an expert in insanity, said Zastera suffered from dementia praecox. His case was progressive and Zastera would grow worse instead of better. Hicks worked for the Essex County Hospital for the insane. He examined Zastera on June 6 and observed him on six more occasions after that. According to Hicks, Zastera suffered from nervous prostration, severe headaches and very defective short-term memory. When put through severe tests, Zastera was devoid of all feelings of pity or affection. While Judge Voorhees listened to the testimony, Zastera, seemingly uninterested, drew a pen and ink picture of the three doctors that testified. At the end, he handed his drawing to an editor of a bohemian newspaper in New York.

Dr. Harvey S. Brown, the jail physician, and Dr. D. McLean Forman of Freehold, agreed with Dr. Hicks, that Zastera was indeed insane. Dr. Brown examined him on three occasions and said Zastera exhibited great egotism, thinking that he was a great musician and artist.

Zastera smiled as he entered a car that would take him from the county jail in Freehold to the state's insane asylum in Trenton. He spent the rest of his life institutionalized. Zastera spent some time in Essex County Mental Hospital in Cedar Grove before dying in Trenton in July 1969.

Who Shot George Harris?

O n July 29, 1913, Special Officer Charles Roberts of Wall Township found a dead body lying under a locust tree on the New Jersey National Guard Encampment Reservation in Sea Girt. In 1913, Sea Girt was a small, unincorporated community of Wall Township. It did not have a local police force and was serviced by officers of the Wall Township Police Department.

The state of New Jersey owned a 120-acre tract of undeveloped land in Sea Girt. It was a permanent camp and had a firing range. The New Jersey National Guard used it for training exercises and rifle practice. During July 1913, the Fourth Regiment was stationed there. They pitched tents and conducted training exercises.

The Governor's Cottage, built just inside the entrance to the camp on Washington Boulevard, became a popular place for United States presidents and New Jersey governors and their families to use as a summer home at the Jersey Shore.

Officer Roberts found the dead body on the lawn across the street from the Governor's Cottage. The Little White House, as it was called, was the summer home of Governor James F. Fielder and his wife Mabel. Governor Fielder had been in town reviewing the troops, but was not in Sea Girt at the time of the crime. This area of Sea Girt was not densely populated. The summer home of Mr. and Mrs. A. Mellon of Philadelphia, called The Farms, was the only cottage nearby that was occupied.

Roberts was making his regular rounds in his patrol car when he saw the body and found that it was riddled with bullet holes. He covered the body with a blanket and went to Harvey Blakely's store. Blakely lived in Sea Girt and was the supervisor of the Sea Girt Water & Sewer Company. He called an undertaker, Robert M. Purdy of Manasquan, and Purdy called Coroner Albert W. Bennett of Belmar.

Governor's Cottage in Sea Girt, where Chief Charles Roberts found the body of mysterious stranger George Harris under the nearby locust trees. *Courtesy of Monmouth County Historical Association Library & Archives.*

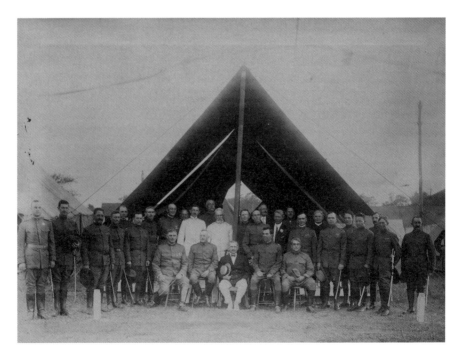

Governor Fielder with officers of the Fourth Infantry Regiment of the New Jersey National Guard at Sea Girt Camp. *Courtesy of New Jersey State Archives, Department of State.*

Coroner Bennett and Purdy arrived and made a thorough examination of the scene. Purdy then took the body to his morgue and made arrangements to bury the body in the potter's field in Manasquan. Purdy believed the man's wounds were not self-inflicted but that it was a case of robbery and murder. In one pocket they found an empty envelope addressed to George K. Harris, Robinson House, which identified the dead man. Harris was dressed in a blue suit. His straw hat found near his body had a Florida trademark. Roberts described Harris as about fifty years old, short and stout, about two hundred pounds. He was cleanshaven with pure white hair.

Harris was shot three times, with bullet holes in his hand, his knee and his head. Roberts found the weapon, a .32-caliber revolver, in Harris's right hand. Three chambers in the gun contained discharged cartridges; four good cartridges remained. Harris's empty wallet was found lying on the ground, open, about twenty-five feet away, as if it had been rifled through and tossed away. Someone had trampled the grass in the surrounding area, indicating that Harris may have struggled for his life.

For the previous two weeks, Harris had been renting a room at David W. Robinson's Boarding House on Mercer Avenue in Spring Lake. Harris had told Robinson's wife, Annie Eva, that he was a widower from Danbury, Connecticut, and had no living relatives. Harris did not associate with anyone else boarding at Robinson's, but seemed to have ample funds. Little more than that was known about Harris other than that he was a professional gambler. Evidently the soldiers at the camp had time to play cards and dice. It was reported that Harris followed the troops from camp to camp for the purpose of winning money from them.

Mrs. Robinson and Coroner Bennett searched his room after she learned that he had died. They found several expensive shirts and three leather bound books, of Shakespeare and Dickens. The quiet, mysterious stranger from Danbury left no other clues in his room to tell about the details of his life.

At Purdy's Morgue, Monmouth County Physician Dr. Harry Neafie examined the body and discovered a cut from a sharp knife on Harris's hand. The cut was about two and a half inches long. There were three bullet holes: one inside the cut of his hand, one in his knee cap and one above his right ear that penetrated the skull and brain. Dr. Neafie noted that there was no powder burn near his ear. Neafie determined that the bullet holes could not possibly have been fired by the deceased and ruled out suicide. Dr. Neafie told Bennett of his findings and his opinion, which were in accordance with Bennett's own assessment. Bennett began an investigation and scheduled a coroner's inquest for August 5.

Monmouth County Assistant Prosecutor Peter Vredenburgh Jr., assigned Monmouth County Detective Elwood Minugh to investigate. For two days,

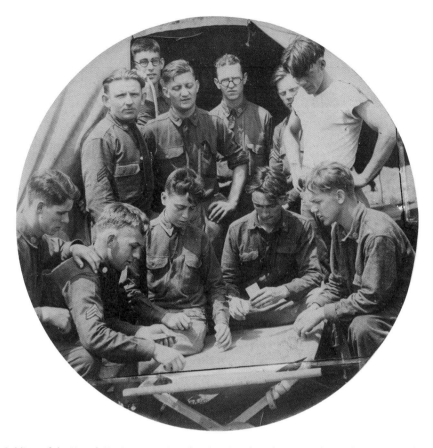

Soldiers of the Fourth Regiment stationed at Sea Girt found time to play cards. *Courtesy of New Jersey State Archives, Department of State.*

Detective Minugh was unable to discover any clues as to the name or whereabouts of any suspected murderer. The only lead Minugh had was that a hotel employee said he had seen Harris playing craps with a foreigner and some soldiers late the night of the crime. Without any further leads or information to investigate, Minugh decided that Harris committed suicide. He asked that the investigation be dropped. Minugh's theory directly contrasted Dr. Neafie's, Coroner Bennett's and Officer Roberts's opinion, but the prosecutor's office agreed to drop the search for the killer.

Upon hearing Vredenburgh's decision, Bennett had said he would engage detectives himself if the prosecutor failed to continue the investigation. He believed several soldiers of the Fourth Regiment of the New Jersey National Guard were involved. The Fourth, with headquarters in Jersey City, was in town using the encampment for training practice. Authorities learned that

a soldier of the Hoboken Company of the Fourth was seen with Harris on several occasions. That soldier's identity was learned but his name was not released to the press.

Three days after the body was found, Officer Roberts still had no idea who killed Harris. When detectives notified Danbury officials, Fairfield County Prosecutor Norman C. Beers replied asking for certain information regarding the body. Danbury policemen were looking for a man involved in a crime there and thought it might be Harris. Monmouth County officials considered exhuming the body.

Two days before the discovery of the body, a foreigner had taken a room in the Sea Girt View House. Mr. Wright Cottrell and his wife Elizabeth owned and operated the View House. Edward Finnegan, a photographer from Newark, was also staying at the Cottrells' House. Finnegan came to Sea Girt on Sunday and rented a room near the bathroom. He saw the foreigner and described him as a Hebrew having dark brown, curly hair, about five feet, six inches tall and about twenty-four or twenty-five-years old. Finnegan said that earlier on the day of the crime, he saw the foreigner receive a visit from a soldier. The soldier stayed about two hours behind locked doors in the foreigner's room. The two left together late in the afternoon. Later that night, Finnegan saw the foreigner returning to his room, then he spent half an hour washing in the bathroom.

The next morning, the foreigner went to the scene of the crime with N.H. McKenzie of 125 Atkins Avenue in Asbury Park. Together they searched about the lawn for clues. A few soldiers joined the foreigner and McKenzie upon their return to the house. Fifteen minutes later the foreigner left the hotel without telling Mrs. Cottrell and was not seen again. Upon learning this, Coroner Bennett summoned Finnegan and McKenzie to appear at the inquest.

Bennett also summoned William H. McCracken and "Mamie" Lang who lived with McKenzie. Officials served them their summons at Flagg's in Asbury Park, where they ran a wheel of fortune. McCracken and Lang admitted being in Sea Girt the night of the murder. They had come by trolley earlier that day and missed the last trolley returning home, so they walked back. The distance between Sea Girt and Asbury Park is about five miles. McCracken said they returned by motorcycle the next day and visited the scene of the crime. He borrowed the motorcycle from Mrs. Cottrell's son Bert.

Chief Roberts received a letter from W.L. Campbell of New York, stating that the murdered man may be the husband of Mrs. George H. Bayles of Plainfield. Bayles's husband was wanted there for wife desertion, and

according to Campbell's letter, Bayles was known to use the alias George Harris from Danbury.

CORONER'S INQUEST

Coroner Bennett held the inquest in Borough Hall at Manasquan on August 5. Jurors were John E. Emmons, James Danley, Edwin Beuse, T.L. Clayton, Clarence L. Rae and Charles Clayton. In the death of George Harris, the jury developed information that led to a strong suspicion of the young male foreigner staying in the Sea Girt View House who disappeared the day after Harris's death.

McKenzie did not appear, but William McCracken and Mamie Lang showed and testified. All three, suspected of involvement, ran a wheel of fortune at Flagg's in Asbury Park.

Testimony came from Liveryman George Farr, employed at the Tremont Hotel and Expressman James Miller. Farr overheard an argument between three soldiers and two civilians. Farr said he heard "eleven dollars" mentioned in the argument. One soldier was accusing one civilian of taking his money. Miller witnessed an argument at the train station and noticed one soldier had his bayonet drawn and was holding it in his hand.

Louis Wilson, another photographer, also was staying in the Sea Girt House that night. Wilson testified that he recognized a smell coming from the foreigner's room and identified it as opium. Wilson said he smelled opium burning at the time a soldier from the Fourth Regiment was visiting the foreigner's room. Wilson said he smelled this odor on several occasions and that several different soldiers visited the stranger's room.

Mrs. Cottrell said the stranger signed the guest book, but his signature was illegible. No one could verify his name.

Dr. James R. Wainwright, who assisted Dr. Neafie in the autopsy, testified that the bullet to Harris's head penetrated his skull and passed through his brain and caused instant death. This meant the wounds to Harris's hand and knee were inflicted first. Dr. Neafie testified that Harris had a cut on his hand made from a sharp knife. Neafie told about the absence of powder marks from firing a gun at close range. As to the doctor's opinion whether the death was suicide or murder, Prosecutor Vredenburgh questioned Dr. Neafie further:

> *Vredenburgh: Could a man fire a revolver, inflict a wound upon himself and leave no powder marks, as this was inflicted?*
> *Neafie: In this position he could not.*

Vredenburgh: That is an impossibility?
Neafie: An impossibility.

The inquest failed to discover any other new clues. In a brief statement, the jury concluded it was murder. They wrote a verdict that simply said, "George K. Harris met his death by person or persons unknown to the jury." Monmouth County Prosecutor John S. Applegate reopened the case to make a thorough investigation but nothing ever became of it.

In New Jersey there is no statute of limitation on murder; the murder of George K. Harris remains an open case. Whether this file still exists is unknown. It may have been destroyed before the law went into effect that required all murder files to be saved indefinitely.

In the end, county officials were unable to prove their theory that Harris, a professional gambler, was killed over an argument while playing craps or cards and/or smoking opium. It seems possible that McKenzie, McCracken, Lang and several soldiers were somehow involved, but most believed that the foreigner, who disappeared within hours after Harris's death, was ultimately responsible for the shooting of George Harris.

Revenge of the Farinella Brothers

O n Saturday night, April 21, 1917, the body of Gondolfo Farinella, thirty-eight years old, was found on the side of the road at Old Bridge, near his store. His body had numerous knife wounds and bullet wounds, leading Middlesex County officials to suspect that two assailants killed Farinella. Gondolfo was the son of Giuseppe and Madalena Farinella of Jamesburg. The Farinella family came from village Villarosa, Provincia Palermo, Sicily, about 1902. Gondolfo Farinella was the father of six young children. After his death, Gondolfo's widow, Mrs. Frances Farinella, and her eldest children Lena and Joseph, managed the store. At the time, Lena was nine and Joseph was ten years old.

Police suspected James Casale of Old Bridge, but never obtained enough evidence to arrest him. In fact, police never arrested anyone for the murder of Gondolfo Farinella. Neither the Middlesex County Prosecutor's Office nor the Middlesex County Archives has any information on this unsolved case.

While still under suspicion, James Casale moved in with Gondolfo's widow and her children. Casale's sudden move surprised Gondolfo's two surviving brothers, Antonio and Samuel Farinella. The Farinella brothers were convinced Casale had murdered their older brother, and now he was living with their brother's widow, in Gondolfo's own house. The brothers considered this intolerable. The situation was embarrassing and something had to be done. Casale's sister, Christina, was married to Samuel Farinella, making Samuel Farinella and James Casale brothers-in-law.

Antonio and Samuel Farinella of Jamesburg in Middlesex County made their living huckstering. A huckster was a retail seller of small goods. The brothers, aged twenty-nine and twenty-seven respectively, bought fruits and vegetables at the Freehold Farmers' Market, located in the lot behind the American Hotel, and sold them to store owners in Perth Amboy and New

Huckster James Casale was last seen alive buying vegetables at the farmer's market in the rear of the American Hotel in Freehold. *Courtesy of Monmouth County Historical Association Library & Archives.*

Brunswick. Business was good during the summer of 1917 as World War I raged on.

During that summer, Casale entered the huckstering business as well. Casale purchased a new Ford delivery truck and started buying produce at the Freehold market. Casale's move pushed the Farinella brothers over the edge. It meant more competition—competition from a man they didn't like from the start. They decided Casale could no longer get away with stepping on their family and now on their income. They decided to put an end to their situation. The Farinella brothers devised a plan to eliminate Casale from their lives—from everybody's lives.

On Friday afternoon, August 17, 1917, the brothers put their plan into action. That afternoon, all three men were busy at the Freehold market buying vegetables. Police believed that Samuel and Antonio coaxed Casale into following them in his own truck to a farm to buy produce. Casale hopped into his truck and followed the brothers as they drove down Jerseyville-Asbury Park Road. He followed them as they turned down a seldom-used dirt road, off into the woods, about one and one-fourth miles east of Freehold.

That afternoon, Jerseyville farmer Daniel Ayres noticed Samuel Farinella drive by in his truck on Jerseyville Road. Charles R. Applegate, who ran a flour and feed mill at the head of the woods, also saw them. Applegate saw

two trucks on the road enter the dirt road to the woods, but only one truck with two men in it exit the woods.

Once there, the brothers turned their truck, blocking Casale's exit. They raised a gun and started shooting. With blood dripping, Casale exited his truck and ran for his life, but it was too late. In broad daylight but hidden in the woods, the brothers pumped six .38-caliber bullets into Casale. One bullet hit Casale in the face, just above his right eye, but that didn't satisfy the Farinella brothers' need for revenge. After they shot him, they took gasoline from their new two-gallon tin can, soaked his body in it and set it afire. Leaving the body in flames, the brothers grabbed the empty can, jumped back in their own truck and sped off. The screw cap to the spout of the tin can lay on the ground.

On their way back to the market, they stopped to bury the can. They picked a boggy area off the side of Gordons Corner Road. They buried the can then wiped their hands clean of gun powder, blood and gasoline. After getting rid of the evidence, they stopped at the Applegate farm and bought some apples, then headed back to the Freehold market.

Farmer John H. DuBois, his son Wilson and hired hand Erick Nagg, were digging potatoes in a nearby field that afternoon when they heard the shots. White potatoes made up the largest farm crop in Monmouth County but that year's weather conditions had caused a slump in the potato market. Farmers were getting only 75 barrels per acre of giant white potatoes, as compared to 110 barrels per acre the previous year. The yield was poor but prices remained good at nearly $3.50 a barrel.

DuBois heard five or six shots then saw smoke rising from the same direction and he saw a Ford truck speeding away. They ran toward where the smoke was coming from and discovered an abandoned delivery car. A little further past the car they saw the body burning. DuBois doused the flames with sand then called the police. The body was too badly burned for DuBois to identify the man.

Monmouth County Detective John M. Smith arrived at the scene of the crime and began his investigation. He found blood stains trailing from the abandoned car. Next to the victim's body, Smith found the tin screw cap from the can and took it as evidence. Detective Smith also noted the tire tracks and footprints in the area. Inside the new Ford truck, Smith found a New Jersey driver's license, issued the day before, belonging to James Casale.

County Physician Harry Neafie and Dr. Warren Fairbanks of Freehold performed an autopsy. Undertaker Clayton of Adelphia took charge of Casale's body.

Farmhands harvesting giant whites in Freehold potato fields. *Courtesy of Monmouth County Historical Association Library & Archives.*

THE SEARCH FOR THE KILLER

Detective Smith went from the crime scene to Freehold market where he told Samuel and Antonio Farinella that Casale had been shot, not realizing he was talking to the murderers. The brothers continued to load up their truck with vegetables, then drove to their father's home in Jamesburg.

After seeing the Farinella brothers at the market, Detective Smith learned that DuBois saw Samuel Farinella on the Jerseyville Road. With that news, Smith realized he needed to talk with the brothers again.

That evening, Samuel Farinella returned to Freehold and entered the Monmouth County Courthouse to see if he could view the body of his deceased brother-in-law. To his surprise, officers immediately took him into custody. With Samuel Farinella behind bars, officers went to Antonio Farinella's house in Jamesburg and arrested him. Both men spent the night in the Monmouth County Jail in Freehold. Both protested, claiming they were innocent.

Police searched Antonio Farinella's house and found a revolver but of a lesser caliber than the murder weapon. At Samuel Farinella's house, they found no revolver, but found hidden under his bed pillow a box of cartridges of the same caliber used to kill Casale. The murder weapon that Detective Smith was looking for showed up in the home of Giuseppe Farinella, father of the two accused men. It was a .38-caliber Smith and Wesson, numbered

237785, and purchased from Perth Amboy gun dealer L. Kaufmann several months earlier. The gun was made of plain metal and had no decorations. Sam Farinella paid twelve dollars for it.

The next day, Detective Smith continued his investigation. From the crime scene Smith followed the Michelin tire tracks past Charles Applegate's farm and down the back road toward Englishtown until he noticed the place where the tracks turned around. Smith made plaster of Paris casts of the tire tracks. He got out of his car and followed two sets of footprints that led to a little marshy place in the woods near Wemrock Lake. Smith saw a spot where the earth was disturbed and with a closer look found a two-gallon tin can. The can was new, evidenced by fresh and bright paint. An old can would have quickly rusted sitting in the watery bog. Resting a few feet from the can, Smith also discovered three badly soiled handkerchiefs. One handkerchief had been used to clean a gun; the others were used to wipe oily hands clean.

Shoe prints pressed in the mud leading from the road to the marsh fit the shoe prints from Samuel and Antonio's shoes. Tire tracks near the tin can and near the burning body matched the Michelin tires on Samuel's truck. With these items as evidence and the witnesses seeing the Farinella brothers on the road coming and going to Jerseyville, detectives felt they had a strong case against the men charged with the crime.

STATE OF NEW JERSEY VS. SAMUEL AND ANTONIO FARNELLS (FARINELLA)

Antonio and Samuel Farinella's trial began before Judge Samuel Kalisch on November 13, 1917. Monmouth County Prosecutor Charles F. Sexton represented the state. Both brothers pleaded not guilty. Defense attorneys James Mercer Davis and Charles M. Atkinson, both of Camden, represented them. Throughout the three-day trial, Antonio Farinella maintained an indifferent attitude.

Monmouth County Engineer George B. Cooper identified the maps he drew of the woods and roads near the crime scene that were traversed by the suspects. Photographer A.L. Hall identified pictures he took of the crime scene. (It is unknown whether these maps and photos were discarded or still exist.)

Mrs. Nettie Applegate, who lived on Jerseyville Road near the scene of the crime, testified that she saw two cars heading into the woods, then shortly after, she heard shots and saw two men emerge in one truck and speed off toward Freehold. Sexton believed the Farinellas convinced Casale

Judge Samuel Kalisch sentenced Samuel and Antonio Farinella to life in prison for killing Casale, Samuel's brother-in-law. *From the Collections of The New Jersey Historical Society, Newark, New Jersey.*

to follow them to a farm to buy vegetables. When they got on the dirt road they pretended to be lost. When they turned around, they blocked Casale's escape and shot him. Police theorized that the Farinella brothers were convinced Casale had shot their brother so they took revenge by murdering him.

Taking the stand in their own defense, Samuel and Antonio both denied that they were on Jerseyville Road that day. Both denied the testimony from Miss Ruth Applegate, who said she saw the two men turn right from the Freehold-Hightstown Road two miles west of Freehold, and then return ten minutes later to her father's farm to buy some apples. Detective Smith testified that he found the can buried only a few hundred yards north of the Applegate home.

In an attempt to gain sympathy with the jury during the last two days of the trial, Samuel's wife, Mrs. Christina Farinella, sat beside her husband with her young children. Christina held five-month-old Lena in her arms while Samuel held two-and-a-half-year-old Katherine in his lap.

The trial lasted three days, but it took the jury just two hours and ten minutes to agree on finding Samuel and Antonio Farinella both guilty of murder in the first degree. The jury returned their verdict with a recommendation of life imprisonment. Judge Samuel Kalisch immediately imposed the sentence as recommended by the jury on each of the men.

Upon hearing the sentence, Mrs. Christina Farinella screamed out against the ruling that would tear her husband away from her and her daughters. Mr. Giuseppe Farinella was sorely disappointed with the verdict and was anxious to appeal, but his sons' attorneys advised him that it was not the time.

Within minutes, Deputy Sheriff J. Arthur Butcher and Warden Michael Quirk escorted Antonio and Samuel Farinella into the police car. The trip from the courthouse in Freehold to the state prison in Trenton was without event, except that Antonio broke down and exclaimed he would rather go to the electric chair than to state prison for life.

Guards at the New Jersey State Prison received prisoners number 4926 and 4927 on the afternoon of November 16, 1917. Samuel was paroled June 27, 1929, and reunited with his wife and daughters; Antonio was paroled June 3, 1930.

Murder in Vetrano's Ice Cream Parlor

On Sunday afternoon, July 19, 1919, Italian immigrant Nunzio Crispo was with his six-year-old daughter Josephine enjoying some ice cream in Carmen Vetrano's Ice Cream Parlor. Vetrano's was located in the heart of the Italian colony in the west side of Asbury Park at 1217 Springwood Avenue. With Crispo were Paul Siciliano and his twelve-year-old son Pasquale "Patsy." It was Mount Carmel Day. The streets were busy with a festive parade and many celebrating Italians. Where red wine flowed freely, the west side of Asbury was alive with activity.

Nunzio Crispo, thirty-three years old, lived right in the middle of the Italian festivities at 1110 Heck Avenue with his wife Rosie, their daughter Josephine and infant son. Crispo was born in Naples, Italy, and had been in Neptune about fifteen years, most recently working as a junk dealer.

That Sunday afternoon, John Vacchiano came into Vetrano's Ice Cream Parlor. Vacchiano, twenty-six-years old, from Provincia de Caserti, Italy, lived with his wife Severia, daughter Josephine and newborn son Steven at 1420 Springwood Avenue.

For the past few years, Vacchiano and Crispo had been embroiled in an ongoing family feud. About six months earlier, the two men were arrested and charged with disorderly conduct. Vacchiano had gone to Crispo's house and challenged him to come into the street and fight. When Crispo refused, he claimed Vacchiano slapped him in the face. The feud, according to Vacchiano, started in a dispute over a card game. Descendants of the Vacchiano family said the feud started over a bocce ball game.

The two families were not strangers to the police force. Vacchiano's brother, Samuel, had been recently convicted for shooting the elder Patsy Siciliano. Crispo's uncle, Gavino, was recently released from state prison for shooting Michael Villepiano. In January 1918, someone shot Vacchiano's

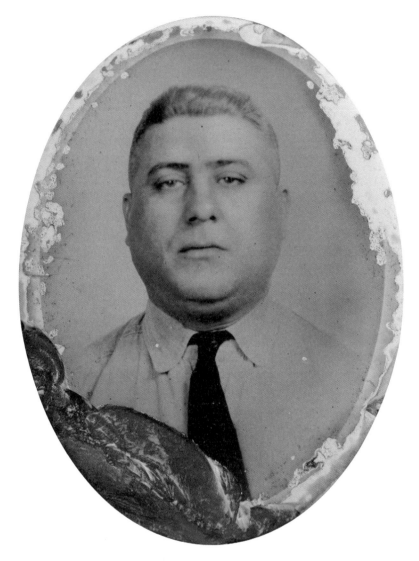

After murdering Nunzio Crispo in Asbury Park, John Vacchiano fled to Milwaukee, where he hid from the law for three years. *Photography courtesy of Bud Benz of Artistic Photography.*

Vacchiano signature. *Courtesy of New Jersey State Archives, Department of State.*

cousin, Pasquale Petrotto, seven times in the back while he walking down a street in Liberty, Pennsylvania.

Despite their long running feud, Crispo invited Vacchiano to sit and have ice cream with them, but he refused. Crispo then offered him a cigar, which Vacchiano accepted. In front of six witnesses, Vacchiano then went right up to Crispo, pressed his gun into his stomach and fired two shots point blank. One bullet traveled right through Crispo, exiting out his back. Vacchiano ran out of the store and disappeared into the crowd. With blood on his hands, Vacchiano escaped. Vetrano called a taxi and rushed Crispo to the Asbury Park Hospital.

Dr. John Taylor received severely wounded Crispo at the hospital that evening, where he and Dr. John Bariscillo made a small incision and removed a .38-caliber bullet. A crowd gathered outside the hospital as word spread through the neighborhood about the shooting. Crispo had a habit of lending money and his relatives knew that many people owed him money. His brother-in-law desperately wanted to get into the hospital to learn the names of his debtors, but Dr. Taylor forbid any visitors. This angered Crispo's relatives and a large crowd gathered and threatened to break in to get the names before he died, in spite Dr. Taylor's protests. Whether anyone got in to see the dying bookie is doubtful.

Crispo died the next day in the hospital on July 20, 1919. Rosie Crispo held funeral services from their home. Father Antonio Giovannini said a High Requiem Mass at Our Lady of Mount Carmel Church. Crispo was a member of the San Gavino Martire Association, whose members attended and eulogized him. Undertaker Harry Bodine took charge of interment in Mount Calvary Cemetery.

THE SEARCH AND CAPTURE

Police searched the local area and continued to run down numerous clues but Vacchiano eluded capture. They broadcast throughout the United States the only picture they had of him, which was a photograph taken when he was seventeen years old.

Five months after the shooting, Vacchiano's wife and children packed their bags and left town for Milwaukee, Wisconsin. At that time, 47,000 of Milwaukee's 500,000 citizens were Italian. It was a good place to hide; one Italian hiding among many in a big city made finding Vacchiano difficult for the police. For nearly three years, using different aliases and working nights collecting garbage for the City of Milwaukee, Vacchiano dodged the police. He gained weight and grew a mustache.

The law finally caught up with him on March 7, 1922, behind Frank Vitucci's Saloon at 222 Jefferson Street. Vacchiano gave his name as Tony Rosso and admitted previously using other aliases such as Tony DelPizzo and Giovanni Chiaravoni.

Milwaukee Detective Louis Dieden received a tip to be on the lookout for a man who was planning to take his own life. Dieden and Detective Emil Hoppe were in Vitucci's Saloon when they heard four shots. They gave chase and caught "Rosso." Vacchiano had a smoking, .45-caliber automatic revolver with him and it was missing four shells. Vacchiano could not explain why he fired the gun, so police held him. At that time, Vacchiano told police he had seven children and was living with his wife at 170 Erie Street. After leaving the scene of the crime in Asbury Park three years earlier, Vacchiano said he spent some time in Pittsburgh then moved to Milwaukee.

Not aware that Detective Dieden understood Italian, Vacchiano began talking with his wife in Italian about murdering Crispo in Asbury Park. Dieden sent a telegram to the Asbury Park Police Department who confirmed the Crispo shooting and Rosso's identity as John Vacchiano, the murder suspect. With this discovery, the Asbury Police agreed to send someone to get Vacchiano. Vacchiano fought extradition, refusing to sign a waiver to leave Wisconsin.

With extradition papers in hand, Monmouth County Detectives Charles O. Davenport and Sergeant Ernest Williams went to Milwaukee and returned to Freehold with Vacchiano in custody. The return trip by rail took nearly thirty-six hours, during which Vacchiano was not handcuffed, except at stations during a change of trains. Williams later testified that on the way back to Freehold, Vacchiano said that he shot Crispo because he had trouble with Crispo over a card game. Williams said the conversation went like this:

> Williams: *Is your name John Vacchiano?*
> Vacchiano: *Yes.*
> Williams: *Is it not Tony Rosso?*
> Vacchiano: *No.*
> Williams: *Why did you use the name of Tony Rosso?*
> Vacchiano: *Because I had a little trouble.*
> Williams: *Trouble you said?*
> Vacchiano: *Yes, trouble.*
> Williams: *Where?*
> Vacchiano: *Asbury Park, New Jersey.*
> Williams: *What trouble did you have there?*
> Vacchiano: *I killed that fellow there.*

Williams: *Whom did you kill?*

Vacchiano: *Se chiame Nunzio Crispo.*

Williams: *Did you kill Nunzio Crispo July 20, 1919?*

Vacchiano: *Yes, that's the day.*

Williams: *Why did you kill Nunzio Crispo?*

Vacchiano: *Because I had trouble with him twice.*

Williams: *What kind of trouble?*

Vacchiano: *Oh, over a card game.*

Williams: *How did you kill Nunzio Crispo?*

Vacchiano: *Well, I was drinking wine that day. There was a celebration. He had brought some compliments at the celebration and wanted to buy one for my wife. She said no. I see him after a while near the poolroom. I walked in there. He no see me. I shoot him, kill him.*

Williams: *Did he know that you were going to kill him?*

Vacchiano: *I don't think so. He don't see me. He sit down.*

Williams: *Were his children around him?*

Vacchiano: *Yes, one child right there.*

Williams: *Well, why did you kill him then?*

Vacchiano: *I was very sore and I drink too much. I don't know what for I kill. I shoot because he make trouble for me two times.*

Williams: *Are you sorry you killed him?*

Vacchiano: *Sometimes, yes.*

Williams: *Why did you tell all this?*

Vacchiano: *Well, I feel better now I tell.*

THE TRIAL

Vacchiano was arraigned March 22, 1922. He entered a plea of not guilty of murder in the first degree. Vacchiano claimed it was self-defense. Attorneys Andrew J.C. Stokes of Freehold and James Mercer Davis of Camden represented him.

The trial began May 23 in Freehold before Judge Samuel Kalisch. Monmouth County Prosecutor Charles F. Sexton represented the state. Sexton produced witnesses who claimed that Crispo never carried a weapon. However, in Vacchiano's defense, Nicholas Vetrano testified that he took a long bladed knife from Crispo's pocket after he was shot. Under oath on the stand, Vetrano continued, saying that he didn't see a revolver but heard that Crispo gave his revolver to another man after the shooting. Stokes objected. Kalisch told the jury to disregard the latter part of Vetrano's comment.

Others that testified included eyewitnesses Harvey Burdge and young Patsy Siciliano. Burdge admitted being present but said he was too intoxicated to remember clearly. Patsy was only twelve years old when he witnessed the cold-blooded murder. Also testifying were Tony Petillo, Tony Carino, Albert Stevenson, Frank Aschetino, Peter Cardillo and Joseph Steinberg.

Detective Dieden came to Freehold for the trial. He testified that Vacchiano confessed to shooting Nunzio Crispo. Dieden said Vacchiano told him he shot Crispo "two times, maybe three," and that his reason for shooting him was that the two had trouble over a card game.

The jury took two hours and twenty minutes to arrive at their verdict of guilty of murder in the first degree with a recommendation of life imprisonment. Judge Kalisch said, "Vacchiano, the jury has taken a very, very merciful view of the circumstances surrounding the death of the deceased; you are indeed fortunate. The sentence of the law and of the court, is that you be confined in state prison for the term of your natural life."

Defense Counselor Davis told Vacchiano that a sentence of life imprisonment really meant a minimum of fifteen years, after which he would be entitled to a pardon if he had a good prison record. Davis explained that the previous winter, New Jersey State Legislature had enacted a law that clarified the meaning of a sentence of life imprisonment as "life" imprisonment. He reminded Vacchiano that the murder he was charged with happened before passage of the new law and it would not apply in his case. Davis was right, but to his client, who had little regard for the law, this loophole didn't mean anything.

Guards at New Jersey State Prison in Trenton received prisoner Vacchiano on May 24, 1922, and assigned him prisoner number 7080. His description upon admittance noted several facial scars and an anchor tattoo on his right arm.

By 1930, Vacchiano had a job in the prison making shoes. Ten years later he applied for parole, and on December 18, 1940, the Court of Pardons granted his request.

Parole

After spending eighteen years of his life behind prison walls, Vacchiano returned to Asbury Park a free man. He rented a room on Pharo Street. Vacchiano met and courted twenty-five-year-old Antoinette Fiorentino of 607½ Church Street. Despite being twenty-years older, Vacchiano wanted to marry the young woman, and in keeping with tradition, asked her parents for permission.

Whether her parents granted or denied permission is unknown, but something triggered Vacchiano's uncontrollable rage. On March 3, 1941,

New Jersey State Prison, Trenton, New Jersey, circa 1900. Prisoners Fowler, Thompson, Lowden, the Farinella brothers, Vacchiano and Martin all spent time behind these thick walls. *Courtesy of Trenton Public Library.*

Vacchiano used a knife to slash his young girlfriend on the face, head, back and hand. Four Fiorentino family members witnessed the attack. Doctors used thirty-two stitches to close her wounds but she survived.

Later that day, Deputy Police Chief George Damon charged Vacchiano with atrocious assault and battery with a deadly weapon. Attorney Vincent P. Keuper entered a plea of not guilty for his client.

When word reached the parole board office, Probation Officer Thomas Mahoney went quickly to Asbury Park and took Vacchiano back to the state prison in Trenton. Breaking parole was considered a very serious offense. Since the parole violation took precedence over the assault charge, City of Asbury Park Magistrate Louis E. Levinson chose to drop the assault and battery charge.

Vacchiano was returned to prison to serve the remainder of his life behind bars. His seventy-five days of freedom didn't last very long. He spent the rest of his life, another sixteen years, behind prison walls. He died in the prison hospital November 12, 1957, and is buried between his two brothers in Mount Calvary Cemetery in Neptune, New Jersey.

8

Moving Picture Operator Elmer Stockton Vaughn

At thirty-four years old, Elmer Stockton Vaughn led a busy life. As a young man, before moving to Asbury Park, Vaughn got his first taste of the movie industry working in the Star Theatre in Trenton. By 1920, Vaughn was a well-known moving picture operator for several prominent Asbury Park theatres, including the Shubert, the Ocean and the Lyric. He ran the Eastern Electrical Company from his home at 64 Franklin Avenue in Ocean Grove.

In the early 1920s, theatre going was a popular pastime. As a projectionist Vaughn's job was to show silent movies to audiences. That summer, the Shubert Theatre at Main Street and Lake Avenues where Vaughn worked featured the 1920 hit *Daredevil Jack*. It featured prizefighter Jack Dempsey in his first acting role in a movie. Dempsey played the part of cowboy Jack Derry. *Daredevil Jack* was a fifteen-episode western adventure that also featured Lon Chaney as Royce Rivers. Dempsey's fame and career skyrocketed as a result of this major hit. Today most of this silent movie series is lost; only portions of episodes one, two and four exist at UCLA's Film Archives. It was Vaughn's job to see that the film played through smoothly for his audiences.

Also during that summer of 1920, Vaughn acted as publicity agent for a Hawaiian troupe, which appeared at the McDonough Cafeteria on Kingsley Street. Vaughn and his wife Lauretta appeared on the vaudeville stage as part of the Hawaiian singing and dancing act. They called themselves the Royal Hawaiian Singers and featured gorgeous costumes, clever dancing, pretty girls and catchy music. Admission for the live entertainment was just fifty cents plus war tax. Evening fare for a balcony seat at the Lyric Theatre was just thirty cents, but the Royal Hawaiian Singers were live entertainment.

Saturday, September 14, 1920, started as usual. Vaughn spent the day helping his wife clean the house. Later in the day he went to get rolls for the

Martin signature. *Courtesy of New Jersey State Archives, Department of State.*

Vaughn showed audiences this 1920 silent movie hit, *Daredevil Jack*, at the Shubert Theatre. It was World Heavyweight Boxing Champion Jack Dempsey's first movie. *Cleveland Public Library.*

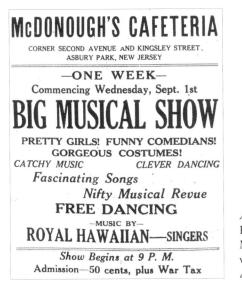

Asbury Park Press advertisement for the Royal Hawaiian Singers appearing live at McDonough Cafeteria. Vaughn and his wife were part of the act. *Courtesy of the author.*

next day's breakfast. He usually went to the market with his brother George. This Saturday night though, Vaughn did not return home. Fred Martin, twenty-one years old, had stabbed Elmer Vaughn to death at the Springwood Avenue railroad crossing. According to the autopsy, the blade of the assailant's trench knife was at least seven inches long. It punctured his lung causing death within an hour. Vaughn died in the Asbury Park Hospital.

Vaughn and his brother George A. Vaughn, thirty-three years old, had somehow gotten into an argument with a gang of black men. What caused the fight to start is unclear. Police theorized it may have started when George, in passing, brushed against one of the five men, but George said that he had not said or done anything to provoke the attack. Witnesses said all five gang members seemed intoxicated, and that the Vaughn brothers were too. Others who knew Elmer said he rarely drank liquor.

A reporter theorized that the feud began during gambling. The reporter guessed that Elmer made enemies by winning all their money so the men picked a fight with him. At the time of his death, Vaughn did have "a wad of bills in his checked-coat pocket," but Mrs. Vaughn took offense to the unfounded accusations. She told police and reporters her husband seldom drank and never gambled. "My husband was good to his family and always had plenty." She said the money he had was paid to him by a customer for electrical work he had done.

At the railroad crossing, someone struck George in the face and knocked him out. Seeing this, Elmer went to his brother's aid and that is when the assailant stabbed him. Witnesses said neither of the Vaughn brothers were

aggressors. They described Vaughn's attacker as a tall, light-complexioned black man. Police would later come to learn that the murderer they were looking for was named Fred Martin.

With a two-inch-deep stab wound, Vaughn walked across the street and fell in front of Compton Restaurant on Lake Avenue. "They got me," Vaughn said as he fell to the ground.

Asbury Park Police Officer Matthew D. Tucker was just around the corner at Paul's Restaurant on Main Street. Tucker had seen the group of five men but was unaware of any crime. He did not recognize any of them. He was in the restaurant looking for a suspect in another case when he heard the commotion. Tucker ran to the railroad crossing to find mayhem.

By the time Tucker arrived, Martin and his friends had fled the scene. Vaughn was slipping into unconsciousness and was unable to tell Tucker the name of his assailant. Tucker called a taxi and rushed Vaughn to the Asbury Park Hospital. Amid the confusion, no one could say where the gang of five men had gone.

Vaughn died in the hospital the next morning. They removed his body to the Bodine morgue, where County Physician Reynolds S. Bennett and Dr. John Taylor did the autopsy.

Search for the Killer

County Detective Charles O. Davenport, Asbury Park Police Chief Horace L. Byram and Detective Sergeant Thomas J. Broderick searched the west side but were unable to find any of the gang. George Vaughn, not knowing that his brother was fatally stabbed, returned to his apartment on the second floor of the Grammar Drug Store on the corner of Cookman and Mattison Avenues.

Through various sources the Asbury Police obtained a detailed description of Fred Martin. He was five feet, nine inches tall and 138 pounds with light brown skin, brown eyes and black hair. His nose was slightly convex and broad at the tip. His chin was recessed and his ear lobes were round and separate. He wore sideburns and a small mustache but otherwise was cleanshaven.

After the stabbing, Martin had gone to Bay Head where his friend Lucretia Armstrong worked as a waitress. Martin later told police that Armstrong gave him money to go to East Orange. She followed him shortly afterward.

A month after the murder, Detective Thomas Edward Hankinson was still looking for the gang of men. He learned that some of the men involved in the fight were in Philadelphia. Detective Davenport went to the Ogontz

section of that city and on October 30, he arrested Irving Toombs, John Green, James Jackson and Alonzo Johnson. Davenport brought all four men back to Freehold and held them on suspicion of murder. All four men said that Fred Martin had stabbed Vaughn. They were held as material witnesses and released on $100 bond.

Hankinson continued his efforts to capture Vaughn's murderer. He had a description from eyewitnesses and now he had the suspected murderer's name. Hankinson never lost sight of this case, eventually tracking down Martin in East Orange.

Seven months after the fatal stabbing, Detective Hankinson came face to face with Martin. On March 18, 1921, Hankinson went to East Orange and with help from the local police, went to the house at 166 Prospect Street. Hankinson saw a man in the backyard beating a bed and at once recognized him as Fred Martin. The sideburns and mustache were gone. Martin was working as a butler.

Martin was living with Lucretia Armstrong, whom he said was his wife but he was not able to produce a marriage certificate. At first Martin denied knowing anything about the Vaughn murder, but eventually admitted to the stabbing. He said one of the Vaughn brothers pulled a knife during the fight, so he pulled his knife in anticipation of an attack. Martin gave Hankinson the knife that he used to inflict the fatal blow. Hankinson charged him with first-degree murder and brought him to the county jail in Freehold where Martin pleaded not guilty.

SENTENCING

On May 25, 1921, Martin retracted his plea and pled guilty to second-degree murder. Judge Samuel Kalisch sentenced Fred Martin to six to thirty years in state prison at hard labor. The next day, authorities at New Jersey State Prison in Trenton received prisoner number 6527. He was paroled January 13, 1926.

Vaughn's widow, Lauretta, had her hands full with four young boys to raise without her husband's help. She died of pneumonia shortly after his untimely death, on January 24, 1923. Her two youngest boys, Frank and Ed Vaughn, were too young to remember their mother or father. Now at eighty-nine-years old, Frank's earliest memories are being cared for in the St. John's Home for Boys in Brooklyn.

Elmer Stockton Vaughn and his wife Lauretta are buried in Mount Prospect Cemetery, Neptune, New Jersey.

9

Camela's Jealous Cousin

On May 7, 1921, the pretty, young daughter of Modestino Maccanico said goodbye to her father. Camela gave him a big hug. It would be the last time they would see each other. Camela left her father on his farm in the village of Ospedaletto D'Alpinolo, Provincia de Avellino, on her way to Naples. There she boarded the S.S. *Giuseppi Verdi* under the command of Captain Vincenzo Romano. She spent the next twelve days at sea, finally arriving at Ellis Island on May 19.

On this trip, twenty-year-old Camela traveled alone. She was five feet, five inches tall, with dark brown hair, brown eyes and perfect skin. From Ellis Island, she continued on to see her sister, Mrs. Anna Grosso. Grosso lived at 146 Fisher Avenue in Neptune, and had invited her sister to stay with her. Shortly after Camela's arrival, Anna's husband, Pasquale Grosso, died of a brain tumor. Anna was distraught and attempted suicide the day after her husband's death, but her cousin, Arico Picone, wrestled the gun from her hands. Picone, twenty-four years old, had come from Brooklyn and he was also staying at the modest home on Fisher Avenue.

During her short stay in Monmouth County, Camela's sweet disposition and attractive looks drew much attention. She made many new friends, including Camanuche Vetrano, a local hackman who lived at 46 Ridge Avenue. Vetrano enjoyed her company.

When Camela was not spending time with Vetrano, she was constantly annoyed by her cousin. Picone worked a week at Tilton Dairy and then another week at the Main Street Theatre. The rest of his time he spent trying to get Camela to marry him, but she refused for the simple reason that they were first cousins.

Eventually Vetrano proposed and Maccanico accepted. It is not known whether Maccanico's consent to marry Vetrano was out of mutual attraction or arranged by a relative. On August 2, her uncle gave her fifteen dollars

to help with wedding expenses. The young couple met with Father Antonio Giovannini who agreed to perform the matrimony and scheduled the wedding for that coming Sunday at Our Lady of Mount Carmel Roman Catholic Church on Springwood Avenue. On August 3, Maccanico and her fiancé went to town hall in Neptune to get a wedding license.

Four hours after obtaining the license to marry, Camela Maccanico lay dead on the dining room floor of her sister's two-story home. Camela's jealous cousin, Arico Picone, shot her through the heart. The bullet passed through her hand as she attempted to thwart her killer's attack.

SEARCH FOR THE KILLER

Mrs. Charles Tyne, in the adjoining cottage, was listening to her daughter playing the piano. She didn't hear a gunshot, but when she was in her bathroom she saw Picone jump out the second floor window. Tyne watched as Picone leapt onto the roof of the shed then into the yard. Her first reaction was that he was playing some kind of game. Tyne watched in horror as she realized Picone was not playing any game. He ran to a corner of the yard, pulled a revolver from his pocket and pointed it toward his temple. Obviously having second thoughts, Picone ran his fingers through his thick hair, which he wore combed straight back, then put the revolver back in his pocket. From the corner of the yard, he jumped over a three-foot-high wire fence and ran down the street.

Monmouth County Detective Charles O. Davenport arrived and spent considerable time observing the scene of the crime on the second floor of the house while a scene of wild excitement developed in front of the home. Women who heard the news fainted. A bunch of Italian men armed themselves with hatchets and shotguns, ready to join in the hunt for the murderous Picone. Vetrano vowed revenge. Maccanico's uncle found one dollar on the floor. With all the commotion on the street, the undertaker, Harry Bodine, had difficulty removing Maccanico's body to his funeral parlor.

Police Chief Benjamin H. White notified Brooklyn police to post a watch at the home of Picone's sister, Mrs. Sarafino Buono, wife of Alfonso Buono, at 5812 New Utrecht Avenue, Brooklyn, but Picone stayed away. Police believed the murder was premeditated, since the investigation revealed that shortly before the murder, Picone went to all his relative's houses and asked for pictures of himself, only to tear them up and throw them away. Police contacted neighboring towns and searched trucks and trains coming and going.

Our Lady of Mount Carmel Roman Catholic Church on the northeast corner of Springwood Avenue in Asbury Park, circa 1920. Instead of officiating at Camela Maccanico's scheduled wedding, Father Antonio Giovannini held a High Requiem Mass at her funeral. *From* Images of America: Asbury Park. *Courtesy of author Helen-Chantal Pike.*

Maccanico's Funeral

The Vetrano-Maccanico wedding had been planned for that Sunday in Our Lady of Mount Carmel Church. Instead, Father Giovannini held funeral services for the deceased young girl. Hundreds of Italians grieved at Maccanico's funeral. Father Giovannini said a High Requiem Mass at the church.

Besides Modestino Maccanico, who remained in Italy, two other relatives were missing from Camela's funeral: her cousin, Arico Picone, suspected murderer still in hiding, and her sister, Anna Grosso. During the funeral, Picone hid in the swampy woods between Fourth and Sixth Avenues, just west of Stokes Avenue in Bradley Park.

Police held Grosso in custody as a material witness. They believed Grosso witnessed the shooting and was concealing valuable information. Grosso would only say that she was in an adjoining room and did not see anything. She refused to say anything else.

Given the excited and heightened emotions of the Italian community, jail was probably the safest place for Grosso. Many believed she was trying to protect her cousin from execution. Some suspected she gave him the money

Maccanico's uncle had given Camela for her wedding. Maccanico's friends and relatives were enraged at Grosso's attempt to shield the slayer. It would be an insult if Grosso really did give Picone the remaining wedding money. In jail, Grosso was at least protected from possible harm.

Slowly the pallbearers carried the white casket that held Maccanico's body into the church. Hundreds of frenzied, grief-stricken Italian men and women lined up to pay their last respects. Some from the crowd forced Father Giovannini to reopen the cover of the casket. In keeping with Italian tradition, they wanted to kiss the dead girl's face one last time. As Father Giovannini raised the lid, a mob of humanity began pushing and jostling for one last caress of the young Italian girl dressed in her white wedding dress.

The agonized screams from mourners and cries from frightened children were so loud that they drowned out the prayers. Men and women cried out as though their hearts were broken. Undertaker Bodine, with help from his assistant Gilbert Leigh, finally replaced the top of the casket. With the other pallbearers helping, they placed the casket in the hearse. At Mount Calvary Cemetery, two Italian women clung to the casket, delaying it from being lowered into the grave.

PICONE'S SUICIDE

On August 10, police received another call about shots being fired in the same house where Maccanico was murdered just seven days before. This time Mrs. Tyne heard the shots and quickly called police. Captain White arrived at the Fisher Avenue house first. He entered the house, went into the dining room on the second floor and found the body of Arico Picone laying dead on the floor, shot four times. His body lay in nearly the exact spot and exact position as Maccanico's was found. White theorized Picone must have snuck in quietly during the middle of the night. The house had been vacant since Maccanico's murder, with Maccanico dead, Grosso in police custody and Picone in hiding. No one saw him enter, and no one saw anyone else enter or leave.

Under Picone's body police found a .25-caliber automatic Mauser pistol. During WWI, German soldiers used this same type of pistol because it did not require a separate pull for each shot. German Mausers fired continuously as long as the trigger was held.

There was no sign of a scuffle in the room and Picone was cleanshaven. His blue pinstriped trousers and shoes were wet. Police found four empty

shells scattered about. One shell lay in the hallway, nineteen feet away from the body. In Picone's pockets, police found twenty-seven dollars and a diary written in Italian.

Again, throngs of Italians gathered in front of the Grosso home. In broken English the police could hear them say the murderer had paid the price for his crime and they were glad. With Picone dead and gone, the band of neighboring Italians ended their search for Maccanico's murderer and returned home.

Chief White and Monmouth County Physician Dr. Charles E. Jamison believed Picone committed suicide. Detective Jack Smith, who also viewed Picone's body at the scene of the crime, believed his death was by his own hand as well, but not everyone felt that to be the case. Sheriff Walter H. Gravatt and Police Recorder Peter F. Dodd expressed doubt as to how someone could shoot themselves four times.

Chief White brought Picone's diary to a friend and had it translated. Picone kept a detailed description as to why he murdered his cousin. The last entry in his book was his suicide note. *Asbury Park Evening Press* published a translated copy. Picone wrote that Camela was being forced into a loveless marriage with Camanuche Vetrano by an uncle. To save her from this tragedy, he killed her.

As published in the *Press*, here is "Picone's Pathetic Farewell":

> *I write these few lines to explain the wrong I have done; to let you know that all this ruin was caused by my uncles. The motive was that my cousin did not want to marry this fellow but they scared her as so that she said "yes."*
>
> *After a week she saw the fellow but did not like him so she left him. When my uncles heard that she didn't want him they threatened her. This was Sunday. Monday they threatened her again, saying that they would kill me and cut her to pieces. If you don't believe me there is her sister. She can tell you better, for when I shot the girl the sister heard everything I said. I said that any girl had the right to marry anyone she liked.*
>
> *In regard to me, it is true I did this wrong. This wrong you would understand better, if you felt like I felt you would not talk. In reality I came to Asbury Park for revenge to kill the ones who were to blame. When I arrived at this village my intentions changed because they had children and so I go to where the soul of my cousin reposes, for there mine is to repose too. This I want to tell, that for this sin they will cry who are to blame.*

According to his diary, Picone pleaded with his uncle to let Camela marry whomever she wanted. She had every right to do so. Picone wrote that his

uncle responded that he would kill him if he got in the way and he would cut her in pieces if she didn't marry Vetrano.

Picone had come back to Neptune with intention of killing his uncle, but changed his mind when he learned his uncle had children. The handwritten entries in Picone's diary ended the dispute about whether his death was suicide or murder. His final entry explained that he wished to join his cousin in death.

Dr. Jamison removed the body from Grosso's home. It was originally to be sent to the home of Picone's sister in Brooklyn, but in a last minute change, Picone was buried just outside Mount Calvary Cemetery in Neptune. In strict keeping with Catholic tradition, anyone who broke the Sixth Commandment, which reads, "Thou shalt not kill," committed a mortal sin and could not be buried in sacred ground. The cemetery had a special row for people like Picone, and it was just outside the blessed ground used for regular Catholic burials. Picone's resting place was called Murderers' Row. However, the cemetery has no records of any burials before 1946, and the final resting places of Maccanico and Picone are unmarked.

The Unwritten Law

"There is no such thing as the unwritten law."

W hat really happened in the Eovino farmhouse on the night of August 8, 1922, depends on whom you believe. We may never know the truth. There is the version from Raffaele "Ralph" Eovino, husband of Amelia Eovino, and then there is the version from Tony Ruggerrio, Amelia's lover and farmhand. What is not in dispute is that Ralph Eovino shot and killed his wife Amelia Eovino that night.

The shooting occurred on the second floor of the Eovino farmhouse at Centreville, Holmdel. The farmhouse was located on a lane off the main road leading from Middletown to Keyport, which is now called State Highway 35. Eovino used an old .38-caliber revolver, which misfired after the first bullet was discharged.

Eovino was a thirty-eight-year-old Italian immigrant farmer. His wife Amelia, who was thirty-one years old, took care of their six children. At the time of the shooting, their five sons and eighteen-month-old daughter, Philomena, were in the house, contrary to the *Asbury Park Press*'s incorrect report of five girls and one boy. The oldest boy, ten-year-old Patrick "Patsy," was sleeping in Ruggerrio's room when the shooting occurred.

Ruggerrio was an Italian farmhand from Brooklyn hired by Eovino a few weeks earlier.

EOVINO'S VERSION

According to Eovino, that night at dinner, Amelia told him that their neighbor, Louis Picola, was ill. She suggested it might be nice if he went over and visited him. Eovino claimed he did not suspect his wife and Ruggerrio were having intimate relations, so he left the house at his wife's suggestion. Eovino had some money in his pocket so before he left, he put

his revolver in his pocket. After dinner Eovino went to Picola's house and found him working in the garden, not at all ill. He talked with Picola for about twenty minutes.

Trouble began when he went back to his own house and found his wife in a compromising position with Ruggerrio in Ruggerrio's second floor bedroom. The bedroom door was slightly open and Eovino walked in and said, "You bum. I'll have you both locked-up."

Eovino said Amelia jumped out of bed and punched him in the jaw. Ruggerrio grabbed a double-barreled shotgun and threatened him. In self-defense, Eovino pulled out his revolver and fired at Ruggerrio but missed. He said he misjudged his aim. The bullet hit his wife and killed her. Eovino fired four more times at Ruggerrio but his gun jammed. The two men fought; Ruggerrio bit Eovino in the finger and ran out of the house. Eovino chased after him with an ax in his hand. Eovino went to his neighbor, Mrs. Rose Curley, and told her to call the police to come and get him because he had just shot his wife. After that he went back to looking for Ruggerrio until police arrived.

RUGGERRIO'S VERSION

Ruggerrio said he went to bed that night about 9:00 p.m. Young Patsy Eovino was already asleep in the room they shared. Shortly after Ruggerrio retired, Mrs. Eovino came into his room and started making improper advances. He told her to leave but she returned and joined him in his bed. When she heard the door open downstairs, she jumped out of his bed and ran down the hall where she met her husband. Ruggerrio said he heard Eovino say, "I told you I was going to kill you," and then he heard the shot ring out. Ruggerrio said Eovino then came into his room, pressed the revolver to his chest and pulled the trigger three or four times but no bullets came out. There was a double-barreled shotgun leaning against the wall in his room, but only Ruggerrio knew that there were no shells in it. He had used the last shells that morning shooting crows. The two men wrestled for the shotgun, but Ruggerrio broke free and jumped out a window. He ran to a nearby store and called the police.

THE ARRESTS

After Red Bank Police station got the call, New Jersey State Troopers George J. Diblin and William H. Pohley, both of Bergenfield, went to the Eovino farm to investigate.

When New Jersey State Trooper George J. Diblin was not busy arresting murderers like Raffaele Eovino, he had time for tricks. Diblin thrilled the crowds riding his Harley motorcycle at the 1922 Monmouth County Horse Show. *Courtesy of New Jersey State Police Museum.*

At the time, Holmdel was a sparsely populated rural community and had no police force of its own. It was the duty of the troopers of the New Jersey State Police to service these types of communities, which they did by horseback or motorcycle. Red Bank was about five miles from Centreville. Most likely, Diblin and Pohley rode their Harley motorcycles to the scene of the crime. As they sped to Eovino's farm, word of the shooting spread through the neighborhood.

When Troopers Diblin and Pohley arrived, they found Eovino a short distance from his house. He was pacing back and forth and wielding an ax. His hand was dripping in blood. Eovino said he was looking for Ruggerrio to kill him. Ruggerrio was hiding in the bushes a short distance away. Pohley noticed the bite mark on Ruggerrio's finger and took Eovino back into his house. Eovino pointed to his wife's dead body. Pohley asked Eovino why he did it. "Because she was with Tony," he replied. The troopers arrested Eovino for murder and arrested Ruggerrio for assault and battery.

Monmouth County Physician Dr. Harvey W. Hartman visited the farmhouse that night. The *Freehold Transcript* reported that Dr. Hartman found the detached head of Amelia Eovino in the kitchen and her body in the shed.

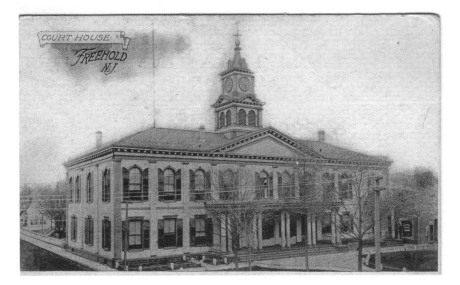

Monmouth County Courthouse, Freehold, New Jersey, as it appeared in the 1920s. To the left in the background is the jailer's house. *Courtesy of author and local historian Randall Gabrielan.*

The next morning, Monmouth County Detectives Charles O. Davenport and Jack Smith took Eovino and Ruggerrio to the county jail in Freehold. Monmouth County Prosecutor Charles F. Sexton charged Eovino with murder in the second degree, but the public sentiment in favor of Eovino surprised county officials. Eovino was well respected by his friends and neighbors. Most of them blamed Ruggerrio for causing the murder.

A day later, Dr. Henry Hopkins, pharmacist and chemist of Keyport, visited the scene of the crime. Hopkins took blood samples from Ruggerrio's bedroom, the upstairs hallway, the stairway and the downstairs kitchen area. Hopkins declared he was reasonably certain that based on the uniform size of the corpuscles, the blood had come from just one person.

With their mother dead and their father in jail, the New Jersey State Board of Children's Guardians, possibly a predecessor of New Jersey's Division of Youth and Family Services (DYFS), began making arrangements to place the children in various foster homes. Two children were moved to homes in Clarksburg.

Someone took a picture of all six children, photographed while sitting on the courthouse steps waiting to be taken to foster homes. What a sad and frightening moment in their lives that must have been for the Eovino children: Patsy, John, Michael, Ameillo, Dominic and little Philomena, all now deceased.

Amelia Eovino's gravestone, St. Joseph's Cemetery, Keyport. *Photograph by the author.*

Amelia Eovino's brother, Mr. Lawrence Pelusso of 224 North Sixth Street, Brooklyn, informed the Holmdel Department of Health of his sister's death. Pelusso reported the spelling of Amelia's last name incorrectly as "Icovino" on her death certificate. He may have been trying to save his sister's name from people learning the truth of her shameful act. Undertaker Harvey S. Bedle handled the funeral services and interment. Amelia is buried in a single grave under a pine tree in St. Joseph's Cemetery in Keyport with a gravestone that simply says "mother."

THE TRIAL

The *State of New Jersey vs. Ralph Icovino (Eovino)* began January 29, 1923, before Judge Samuel Kalisch in the Monmouth County Courthouse in Freehold. Eovino pled not guilty in self-defense. Attorney Cecil S. Ackerson defended him. Monmouth County Prosecutor Charles F. Sexton presented the state's evidence.

The trial lasted two days. Ruggerrio told his version. The doctors told of their findings. Several neighbors testified as to the good character of Eovino. The detectives took the stand, as did the two troopers. Trooper Diblin stated that he heard Eovino tell Trooper Pohley, "I meant to kill both of them."

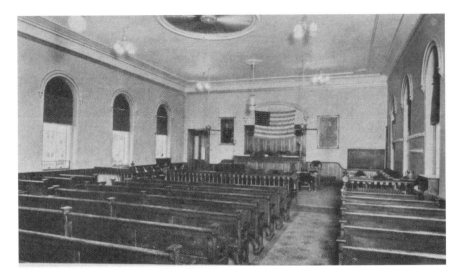

Interior view of a courtroom in Monmouth County Courthouse, circa 1929, where murderers received jail terms. *From "A Sketch of Monmouth County, 1683–1929," by the Monmouth County Board of Chosen Freeholders. Courtesy of Matawan-Aberdeen Public Library.*

Eovino took the stand in his own defense. He testified under oath that when he found his wife with Ruggerrio, they attacked him. To counteract Diblin's testimony, Eovino said, "I was so excited at that time I don't know what I told the officers that night."

In summation for the defense, Prosecutor Sexton reminded the jury that there is no such thing as the unwritten law. In charging the jury, Judge Samuel Kalisch said, "In my opinion, the ends of justice will be met if you find that the defendant shot his wife and not in self-defense of his own life and if you find a verdict of manslaughter."

After fifty minutes of deliberation, the jury found Eovino not guilty. Judge Kalisch was not satisfied with their decision. In a crisp voice Kalisch said, "No doubt the wife of this defendant was guilty of a very immoral act. She was caught in the very act of adultery by her husband. This is great provocation, but not sufficient to absolve this defendant from the consequences of his act. The state does not recognize any such thing as the unwritten law. I am sorry to say, gentlemen, that I do not agree with your verdict."

The jury chose to disregard the evidence and use their interpretation of the "unwritten law" to decide Eovino's fate. Unwritten law generally consists of customs and traditions of human conduct that are accepted in culture but not included in the written rules of the governing body. Primitive law evolved in this manner. Much international law is unwritten, based on useful

In the Court of Oyer and Terminer of Monmouth County, May Term, in the year of our Lord one thousand nine hundred and Twenty two

Monmouth County, To Wit:

THE GRAND INQUEST of the State of New Jersey, and for the body of the County of Monmouth, upon their respective oaths

Present, that Ralph Icovino

late of the Township of Holmdel in the County of Monmouth, on the Eighth day of August in the year of our Lord one thousand nine hundred and Twenty two with force and arms, at the Township of Holmdel in the said County of Monmouth, and within the jurisdiction of this Court. One, Amelia Icovino then and there being in the peace of God and this State, wilfully, feloniously and of his malice aforethought did kill and murder, contrary to the form of the statute in such case made and provided and against the peace of this State the government and dignity of the same.

Monmouth County Murder Indictment for Ralph Icovino (Eovino). *Courtesy Monmouth County Archives, Manalapan, New Jersey.*

tradition and widely practiced behavior, and it still exists today. Retaliation to terrorism is an example of current unwritten law.

In this case, Eovino was a well-respected farmer. His neighbors testified to his good reputation. The jury saw his wife as guilty of breaking the law. Husbands expected their wives to remain loyal to the marriage vows they had sworn to uphold. Eovino's wife disgraced his family, and as the jury saw it, it was not the husband that did wrong. The jury was able to use Eovino's testimony that he shot in self-defense, to find him not guilty. So in 1922, the unwritten law applied to this case allowed Eovino to go free: *A man may shoot his wife if she is caught committing adultery.*

Despite Kalisch's declared discomfort with the verdict, Eovino was set free. All six children were retrieved from the foster homes and reunited with their father. Eovino's parents and brother's family helped them get back on their feet. Raffaele Eovino eventually got a job working for the Central Railroad of New Jersey and died in 1965. He is buried in St. Joseph's Cemetery but in a different section than his wife.

Unthinkable Filicide

"It seems like an awful dream."

T he Stoble family of Red Bank, New Jersey, lived at 151 Bridge Avenue in March of 1927. Michael Stoble and Christina Calandriello were Italian immigrants. They married in Red Bank about 1906, moved to Staten Island for a while, then returned to Red Bank. They were the proud parents of ten children, including their eldest daughter, sixteen-year-old Rosina.

According to neighbors, the Stobles were a nice, quiet family. They had no previous trouble with the law. Mike Stoble worked as a gardener and Christina stayed home to raise the family. Mrs. Stoble imbued the customs of her religion and her country into her children, especially in regard to children born to unwed mothers. Based on her deep Catholic religious beliefs, having an illegitimate child was a sin. It was not necessarily the birth of a child out of wedlock that was sinful. It was the act of having premarital sex, which was, and still is, against canon law in the Catholic Church. Ethnically, it would be a family disgrace. Her neighbors would think it shameful that a mother failed to teach her children how to behave properly.

Christina, for several years, had been in and out of doctors' offices with various ailments. She eventually asked Rosina to stop attending Catholic school to help raise the children. Rosina agreed and at first was very patient and caring with her younger brothers and sisters. "Rosie," as her sisters and brothers called her, was a big help to her mother, but after about six months of staying home and helping, Rosina's personality changed. She became cross to the children, and angry. Her parents didn't understand why this was happening to their daughter. In the mornings, Rosina began seeing someone only identified as "a man named Mike." When confronted about her visitor, Rosina denied everything, but the neighbors said they saw her with him. Nearly every morning Rosina and Mike met and talked on the front stoop. Christina tried, but could not get her daughter to say anything about the man named Mike.

The house at 151 Bridge Avenue in Red Bank still stands, where in 1927 Christina Stoble murdered her daughter in the cellar. *Photograph by the author.*

Rosina became pregnant and tried to hide it. Time after time her mother asked, "What is wrong? What are you worried about? Why are you sick?" The young Rosina replied she had a headache or stomachache and wanted to be left alone. As mothers have a way of knowing all things, Rosina's mother knew her daughter was pregnant. Christina worried that if her husband found out, he would kill his daughter, so she hid his revolver in the cellar where he would never find it.

THE NIGHT OF THE MURDER

Late in the night of March 6, the young, unwed and pregnant Rosina got out of bed and went to the cellar, obviously in pain. She lay down on a pile of rags and gave birth to a son. Her mother heard her and followed

her down the stairs. Rosina said, "Look, see, see, see; look who is here." The instant Christina saw the baby, she grabbed her husband's gun from the shelf and shot her daughter in the face. Rosina got up with her baby in her arms and ran up the stairs to the kitchen, but her mother fired two more bullets, shooting her daughter in the back as she tried to escape. The screams and the gunshots woke everyone in the house.

Mike Stoble ran to the kitchen when he heard the shots. The children met their father there and when they realized what had happened, they became very frightened. Mike was in a rage. The children didn't know what to do. Joseph, the eldest son, took the gun and buried it in the backyard. In shock and disbelief, Mike told his children to call Dr. James W. Parker and to tell him to bring his ambulance, as well as undertaker Albert J. Worden Jr. Worden arrived and telephoned the local police about the tragedy, since none of the family members had done so.

Red Bank Police Officer Sprigg Williams, on patrol nearby, arrived shortly after Worden. Officer Williams called Police Chief Harry H. Clayton. When Williams entered the house, Mike Stoble greeted him at the door, then he saw Rosina on the kitchen floor. Stoble's daughter Christine led Officer Williams upstairs where he found Mrs. Stoble locked in her bedroom. Joseph unlocked the door, brought his mother down and asked Officer Williams to take his mother away. Williams called a taxi and waited outside, then he took Stoble to police headquarters.

When Chief Clayton arrived at the house, Williams and Stoble were already at the police station. With help from Monmouth County Detective William S. Mustoe, Clayton looked for the murder weapon and took statements from two of the elder Stoble children, Joseph and Christine. Worden took Rosina and the baby to the Monmouth Medical Center in Long Branch, but both died on the way. When Joseph realized that his sister wasn't going to live, he walked to the Worden Funeral Parlor to make arrangements for the burials. Along the way he threw away the empty cartridges taken from his father's gun.

At police headquarters, Williams charged Christina with the murder of her daughter. Stoble, calm and unemotional, agreed to make a complete statement. She described in detail everything that happened that night. Stoble showed no signs of grief and never once asked about the condition of her daughter. Stoble said, "I'm glad I did it instead of (my husband) Mike. He is a good man and never got into trouble." She told Williams, "I did it because I did not want her father to go to the electric chair."

THE CONFESSION

Chief Clayton stayed up until dawn interviewing Stoble and getting the confession although she needed no prodding. Stoble talked freely, without the need for many questions. As Stoble narrated the events, Vernon Rose, a court stenographer recorded what she said in shorthand, then later typed his notations. Stoble talked quickly in broken English; Rose had to occasionally ask her to stop or repeat what she said. Rose sat very close to Stoble as she explained what happened that night.

> *I was in bed. We leave all the doors between the bedrooms open and I heard my daughter Rosina get up. I said "Where are you going?" She said "Shut up! I am going downstairs. Go to bed." I go after her. I thought she was going away from the place. She was all dressed except the top dress. She started down cellar and I said: "What are you going to do down there?"*
>
> *I followed her. She seemed to be in pain. At the bottom of the stairs there was some old dirty clothes and things in a pile, and she sat down on them. I said "I'm freezing down here" and she said "Go upstairs." I said I could not leave her. Then I saw that she had a baby. I couldn't look no more, so I shot her. Maybe if the gun wasn't there I wouldn't have done it. I run upstairs with the gun in my hand. It got out of my hand somehow in the kitchen. I don't know how. My son grabbed me and took me upstairs. My husband said "Hurry with the ambulance. Maybe we can save her." That's all.*

After her statement was typed, Monmouth County Detective Amerigo Sacco began reading it back to her in Italian, but Stoble said, "You're wasting your time, I can understand English." Chief Clayton read it back to her in English. Stoble signed it. Normally people who could not write their name would make their mark with an "x," but in this case, Stoble marked her typed confession with a cross.

The next day, Monmouth County Detective John Smith moved Stoble from the Red Bank Jail to the county jail in Freehold. Along the way, Smith asked her if she was sorry. "No, she disgraced me," she replied.

A week later, from behind bars in Freehold, Christina Stoble sobbed as she talked to a newspaper reporter from the *Asbury Park Press*. "I don't know how it happened. It seems like a dream, an awful dream. Oh, I wish I would wake! I wanted my children to grow up to be good men and women, to go to school and learn things and to marry and have good homes. Yesterday it seemed that I had everything in the world to live for. Today, I wish that I had killed myself."

At the Stoble home in Red Bank, Mike Stoble had nothing to say to reporters. His replies were curt, and he would not tell them if or when he was going to the funeral.

The Autopsy

Rosina's body lay at Worden's Funeral Parlor, as did her baby's body. Monmouth County Physician Harvey W. Hartman of Keyport, Dr. William G. Herman, an X-ray specialist of Asbury Park and Dr. David Cassidy of Keyport performed the autopsy. Doctors Hartman and Cassidy examined the baby's body.

They found three bullets in Rosina. The first one entered near the jaw bone. The second one entered the back and lodged in her shoulder. The third bullet also entered the back and punctured her lung, causing death.

According to their report, the infant lived ten minutes after birth. Death of the baby was due to "hemorrhages caused by lack of proper attention immediately after birth."

The Funeral

Services for both Rosina and her baby were held at St. Anthony's Roman Catholic Church with Reverend Nicholas Soriano officiating. Mike Stoble wept through the entire ceremony. Interment was at Mount Olivet Cemetery in Middletown.

Jury Selection

For this term, the court summoned one hundred petty jurors. It was the largest number of jurors ever called at any term in the history of Monmouth County. By being called first, Earl Snyder of Atlantic Highlands became foreman of the jury. Snyder was in the insurance business and the son of former Mayor Charles R. Snyder.

Another first in Monmouth County history occurred in connection with this trial, when for the first time women were summoned to serve as jurors. The list included two women, Mrs. Mary J.W. Strong of Brielle and Mrs. Gertrude Scott of Red Bank. During questioning Strong was dismissed. The defense excused fifteen jurors, the state excused five and

both sides consented to dismissing twenty other potential jurors. Anyone having conscientious scruples against capital punishment was automatically relieved from serving jury duty.

FIRST FEMALE JUROR

Mrs. Scott, who listed her occupation as housewife, was the mother of a son and daughter and the wife of Dr. Elmer E. Scott of Red Bank. She was selected by both prosecutor and defense as the eighth juror—deemed a person capable of rendering a fair decision. Mrs. Gertrude Miller Scott was the first woman to serve as a juror in Monmouth County, New Jersey. After the trial was over, Scott told reporters, "It was a tough night, but I'm glad I stuck it out." She said every woman should get the chance to serve jury duty. This county-first in New Jersey occurred rather early when compared to other states allowing women to serve as jurors. As late as 1943, only twelve states permitted women to serve. Texas didn't permit women to serve jury duty until 1954 and it wasn't until 1966 that all states allowed women to serve.

THE TRIAL

The *State of New Jersey vs. Mrs. Christina Stoble* began April 19, 1927, in the Monmouth County Courthouse in Freehold before Judge Frank T. Lloyd. The big courtroom was packed with spectators. Every seat was filled and people were standing in the aisles. Many people were left to stand outside the courtroom. An unusually large number of women were present. When Judge Lloyd entered and saw how crowded it was in the room, he instructed the court attendants to allow in only enough people to fill the seats at the start of the afternoon session. Some brought their lunch and ate in the courtroom between sessions, so as not to lose their seat.

Monmouth County Prosecutor John J. Quinn presented the state's evidence. Quinn said if the jury convicted Stoble, he would leave the decision of punishment—either execution or life imprisonment—solely up to the jury. Prosecutor Quinn was prepared to show Stoble as a cold, scheming woman, callous and remorseless, who selfishly killed her daughter to spare her family the shame of an illegitimate child. Quinn said Stoble had an uncontrollable and uncurbed temper.

Former Essex County Prosecutor J. Victor D'Aloia represented Stoble, who pleaded not guilty to murder in the first degree. Stoble's brother John Calandriello of Fair Haven paid for his sister's defense.

Pictured here with her young daughter Ellen, Mrs. Emma Gertrude Scott was the first woman to serve jury duty in Monmouth County, April 19, 1927. *Courtesy of Scott's great-granddaughter Nancy Henrichs.*

At 11:15 a.m. on the morning of the trial, Constable Pittinger and Barney Feltman escorted Mrs. Stoble from her jail cell to the courtroom. Expecting a battery of cameramen, Stoble wore a thick black veil that partly hid her face. Cameras clicked away. Stoble entered the courtroom dressed in black. She required the support of two attendants then lifted the veil as she sat between her lawyer and her brother. D'Aloia based his client's defense on temporary emotional insanity. D'Aloia showed Stoble as a caring mother, fond of her children, who despite her health, tried to make the home bright and help them with their education. He claimed his client was mentally irresponsible. D'Aloia said that Stoble "was off the track. She saw a fate for her daughter worse than death and that what she did was a vagary of the brain that we cannot understand. It was the mother instinct. She did what she thought was best. She had no control over her conduct and could not tell right from wrong."

Mike Stoble came to the courtroom dressed in an army overcoat with the collar turned up. He took a seat with the courtroom audience directly behind his wife but separated from her by the court railing. During the entire proceedings he wore a blank expression and stared down at the floor. He paced the streets of Freehold during the nights of the trial.

THE TESTIMONY

According to the doctor's testimony, Stoble suffered from scarlet fever, diphtheria and epilepsy. Dr. Anthony Maratea of Newark treated her for scarlet fever between 1920 and 1922. Dr. J.G. Fazaresi of Staten Island said he treated her for nervous disorders, and Dr. Felix Francesco of Long Branch treated her for epilepsy. Francesco saw Stoble about a dozen times from 1923 to 1925 and gave her bromides.

Two of the Stoble children gave testimony against their mother. On the night of the murder, Joseph had given a signed statement to the police. His statement detailed what he heard and saw that night. However, on the witness stand, Joseph told a very different story that conflicted with his statement. He explained finding the gun on the kitchen floor and hiding it but denied what he had reported earlier, that his mother told him "to go downstairs and see what's there; I killed her." Stoble showed no emotion as her son took the stand. Joseph grudgingly identified the gun. He said he didn't pay any attention to what his father was doing that night.

Christine, now the eldest daughter, testified against her mother. She spoke in a low, barely audible voice, to which D'Aloia objected to several times. She told of hearing the gunshots, seeing the body on the kitchen floor, going upstairs and finding the door locked. Christine quoted her mother as

saying, "I am sorry I did it." Prosecutor Quinn asked Christine about the man named Mike.

> *Quinn: Did you know Mike?*
> *Christine: No.*
> *Quinn: Did you call Mike on the phone?*
> *Christine: No.*
> *Quinn: Did you ever see Mike there when your mother was home?*
> *Christine: No.*

Both sides presented testimony regarding Stoble's state of mind. For the state, Dr. Henry A. Cotton, medical director of the New Jersey State Hospital in Trenton, declared that Mrs. Stoble was entirely sane.

D'Aloia put two doctors on the stand, Dr. Christopher C. Bealie, a nerve specialist from Newark, and Dr. Ambrose F. Dowd, a member of the medical staff of the New Jersey Department of Institutions. Both refuted Dr. Cotton's testimony. Dr. Dowd described Stoble's condition as similar to shell shock. Dowd found Stoble to be suffering from disassociation from reality resulting in an amniotic condition brought about by the shock of seeing Rosina's newborn baby.

Stoble Takes the Stand in her Own Defense

Dressed in black and looking wan, Stoble took the stand in her own defense. In complete denial Stoble said, "Nothing can make me believe that Rosina is dead." She again denied that Rosina was dead when she was asked to recount her children's names and ages: "Joseph 18, Thomas 17, Rosina 16, Christine 14, Rocco 12, Anthony 11, John 9, Millie 7, Maggie 5 and Anna 2."

Christina said that from the time she saw her daughter with a baby, she remembered nothing until she woke up in jail. She denied killing her daughter, locking herself in her bedroom, being interviewed by police and making statements to detectives. Christina Stoble could not remember any single act of an incriminating nature. Judge Lloyd asked, "Are you in your right sense?" Stoble replied she was not sure.

The Summations

In his summation, Prosecutor Quinn said, "I am not a seeker after blood. Execution is too good for this woman. Do not be swayed by sympathy.

Do not let alienists pull the wool over your eyes. It will be a travesty upon justice and right if this woman is allowed to go free. She is devoid of human sympathy and conduct. She is cold. The state asks you to do your duty." Quinn asked the jury to find Stoble guilty of murder in the first degree and contrary to what he said earlier, he asked for a recommendation of life imprisonment.

In the defense's summation, D'Aloia emphasized temporary insanity. D'Aloia said, "If her mind was disassociated from reality she did not know what she was saying." He concluded, "Ladies and gentleman of the jury, I beg of you to leave this to Almighty God to decide. God is the only one who understands what was in that distorted brain that night. There is no other case like this on record. Give this woman the opportunity to go back to her home. She has been punished enough. I ask you for a verdict of not guilty."

Spectators applauded as D'Aloia finished speaking and took his seat. The clapping angered Judge Lloyd. He stood, red-faced, and demanded that all who clapped be removed from his courtroom. After finding no one to remove, Lloyd said, "Those who so degrade themselves or abuse their privileges, I will send to jail." From then on the courtroom was quiet.

Judge Lloyd wanted the conviction. He denounced the temporary insanity plea as "so fictitious that it nearly fell of its own weight." Lloyd declared her crime an act of a "fiend incarnate."

THE VERDICT

The jury had a difficult time coming to a conclusion. After nearly a full day of discussion, they came out and announced they were unable to agree. Judge Lloyd sent them back for fifteen more minutes of deliberation with the vague threat of keeping them overnight a second night until they decided. Twelve minutes later the jury returned.

"Ladies and gentlemen, have you reached a verdict?" asked Court Clerk Joseph Thompson. "We have," replied Jury Foreman Earl Snyder. "We find the defendant guilty of manslaughter." Mike Stoble slumped down in his seat.

On April 22, after twenty hours of deliberation, the jury had found Christine Stoble guilty. Judge Lloyd was clearly upset with the sympathetic verdict. He immediately sentenced her to ten years in prison, the maximum allowed. "My only regret is that I cannot give you a more severe sentence than the maximum provided for under the verdict." Stoble continued to look disinterested throughout the verdict and sentencing. Judge Lloyd said

to her, "You have been found guilty of manslaughter. Is there anything you have to say?" Stoble merely replied, "I don't understand."

Court attendants escorted Mrs. Stoble back to her jail cell. Many photographers were there to get a picture of the woman murderer, despite the anguished cries from Mike Stoble, "No, no, don't take her picture!" Back in her jail cell, Stoble's demeanor changed drastically. "It's a lie, it's a lie!" she shouted to reporters from behind bars. In anger she threatened, "I'm going on a hunger strike!"

On April 26, 1927, Warden Charles White and his wife Everett Barkalow, a jail guard, took Stoble to the New Jersey State Prison in Trenton. In 1929, authorities transferred prisoner number 9758 to the New Jersey Correctional Facility for Women in Clinton, New Jersey, where she served out her time.

UNANSWERED THEORY

As if the subject was taboo, none of the local newspapers investigated or reported anything on the father of Rosina's baby other than to say he was "a man named Mike." In a thorough search of several local newspapers, not one reporter mentioned as much as the age of the father of the baby. If the father was Rosina's friend or neighbor or classmate, there should have been something written about it. The one circumstance that would make this subject taboo would be incest. With no more facts other than the obvious exclusion of any information regarding the father, it is possible to theorize the father of Rosina's child, briefly mentioned as "a man named Mike," could easily have been her father, a man named Mike Stoble.

Why else would Christina shoot her daughter and not the baby? Shooting the baby would eliminate the family disgrace. That's what the illegitimate child was all about—family disgrace. Shooting her daughter eliminated any chance of discovering the truth about the identity of the father, as long as "the man named Mike" kept quiet.

Gypsy Joe Slays His Fortunetelling Wife's Lover

Max Turnow liked to go fishing. During the summer of 1928, Turnow made his living as a carpenter in Nutley, New Jersey, but whenever he got the chance, he visited the Jersey Shore. He enjoyed the crisp salt air and the sea gulls that squawked for a taste of his catch. Today the same sights and sounds attract many visitors to the popular shore area.

Turnow, fifty-three years old, was born in Berlin, Germany, and lived with his Aunt Bertha Turner at 185 Coeyman Avenue. He had come to the United States as a child with his parents Paul and Bertha Turnow, who lived at 87 Cameta Avenue in Rutherford. He had gray eyes and light brown hair. Turnow was separated from his wife Mary who had custody of their two children, thirteen-year-old William and eleven-year-old Elsie. Mary and the children continued to live with her in-laws after Max moved out.

When Turnow wasn't fishing, he enjoyed the excitement of the entertainment on the Keansburg Boardwalk. The boardwalk offered an assortment of rides, games and food, but Turnow's habit was to visit one place in particular. Turnow liked to have his fortune read. He became especially attracted to a young and mysterious woman known as Rosie the Fortune Teller. Turnow visited her frequently at the gypsy shack and always brought her candy. Rosie's husband, palm reader Gypsy Joe, started to get suspicious about Turnow's gifts and frequent visits to his wife.

Toward the end of the summer of 1928, Max and Rosie's relationship developed into more than just fortunetelling business transactions. On August 12, 1928, Max finished work and headed south. His cousin thought he was going on his typical fishing trip, wearing his gold watch and having about $20 in his pocket. His aunt, Mrs. Frederick Turner, said he was planning on buying a bungalow in Keansburg and had $500 dollars with him. That was the last time they saw him alive.

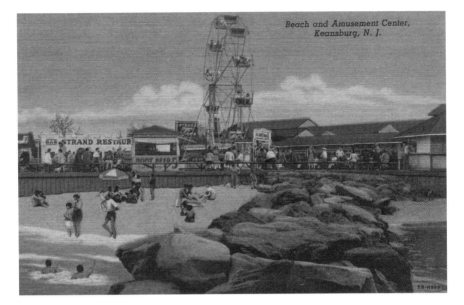

Keansburg Boardwalk, where Rosie the Fortune Teller plied her trade, and where her husband Gypsy Joe disposed of Max Turnow's body. *Courtesy of the author.*

Three days later, on August 15, a body was found floating in Raritan Bay, about a half-mile offshore near the Keansburg Pier. A passenger aboard the southbound *City of Keansburg* spotted the body. Passengers crowded the rail to get a good look. Since the ship was so close to port and there were no signs of life in the floating body, the captain decided to make port without stopping.

The *City of Keansburg* was one of the steamboats of the Keansburg Steamboat Company, owned and operated by the Gelhaus family. The steamship made daily runs to Battery Park in nearby New York City and offered food, live music and dancing.

At the dock, Kenneth Gelhaus, nephew of steamboat company owner, William Gelhaus, set out to see if he could retrieve the body. Gelhaus went out in a motorboat, located and secured the body to its side and towed it into the dock. A crowd gathered as Gelhaus arrived with the body in tow. On the dock, a quick search of the dead man's pockets revealed some papers and a photo of himself. The gold watch was gone and no money was found. No one on the dock recognized the carpenter from Nutley.

Monmouth County Physician Dr. Harvey W. Hartman arrived and pronounced him dead but determined the cause of death was not by drowning. Dr. Hartman observed a deep slash on the back of his neck, almost from ear to ear, and declared death occurred as a result of the wound

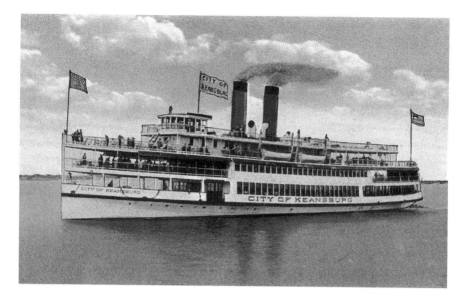

Passengers aboard the *City of Keansburg* spotted the body of Max Turnow floating offshore as the steamship approached the Keansburg dock. *Courtesy of Monmouth County Historical Association Library & Archives.*

made by a sharp instrument held in an unknown person's hand. That conclusion made it a murder case. From there the body was removed to the Bedle Morgue in Keyport.

Monmouth County Detectives John M. Smith and Amerigo W. Sacco spent the entire day investigating. They found an address on his papers and mailed a letter to that address. They showed the photo found in the dead man's pockets around the vicinity, but no one could identify him. They began to think that the murder happened on a boat offshore or in a different town, and that the body just happened to have floated up near the Keansburg Pier.

THE GYPSIES

Earlier that spring, a band of gypsies had quietly moved into Keyport. Their arrival to this area was an annual event. Some stayed in the Mauro Building on First Street and others stayed in the Rapp Building on Lower Broad Street. About twenty gypsies had set up camp in town. The women from the tribe made daily trips to the gypsy shack on the Keansburg Boardwalk to work as fortunetellers and palm readers.

The roving life of a gypsy in these times was not easy. The gypsies had a way of travel known as "patteran," where the first family to travel to a new

place would leave a series of signs, unnoticed by non-gypsies, but as plain as day to those who knew what to look for. These roadside tokens formed maps for the rest of the tribe to follow. Leaders would stop to make a pile of twigs or stones and place them at strategic crossings for followers, who may have been days or hundreds of miles behind.

The families were from Romany, and their first concern was their immediate family. Extended families made up tribes; each tribe had a ruling chief. Their adherence to tribal custom was a way of life—a priority—even to the extent of following their custom over and above the local custom and law. Gypsies were not known for paying taxes or serving in the armed forces and sometimes alienated locals by speaking in their own language.

According to Keansburg lifetime resident Doug Foulks, the gypsy women were very flirtatious. At age thirteen, Foulks worked in a refreshment stand on the boardwalk. The gypsy women would come over when they saw him. They enjoyed visiting his stand and talking with him. Once while they were talking, a gypsy boy named Archie came over. He noticed the girls talking with Foulks. Archie asked Foulks if he liked one of the girls. "She is my sister. Do you want to marry my sister?"

Foulks said that year after year the gypsies would arrive at the beginning of summer and leave every fall. He described their fortunetelling booth as heavily draped in fancy folds. They had a table in the center where a teller would beckon the boardwalk crowds to come in and have their fortune read. They wore colorful skirts and shirts, with beads, bracelets, jewelry and a tiara embedded with special stones. Foulks remembered that the fortunetelling booth was still on the boardwalk as late as 1942.

In Rutherford, Mrs. Turnow received the letter from the police. She went to Keyport and identified the body as her husband. Information she provided led police to raid the gypsy shack. There, Keansburg Police Chief Charles A. McGuire—the first chief of police in Keansburg—along with detectives Smith and Sacco, discovered bloodstains on the floorboards. They also noticed saw marks, as if someone had tried to get rid of evidence. When they visited the gypsy quarters in the Mauro Building and the Rapp Building, they found bloodstains on two dresses and two pairs of pants. On August 22, Chief McGuire arrested four gypsies: Rosie the Fortune Teller and her husband Gypsy Joe, and Rosie's brother Nick Wallace and his wife Ruby. Police took nine other gypsies in for questioning. Chief McGuire held all four on suspicion of murder.

The correct names of these gypsies differed widely as reported in newspapers. The *Asbury Park Press* initially reported the two gypsies arrested as Rosie and Joseph R. Yurka but the following day changed their spelling to Rosie and Aristo Jerke. On both occasions the *New York Times* followed the

newspaper's spelling changes. Both the spellings contradicted how reporters from the more local *Keyport Weekly* and *Matawan Journal* spelled the names. In these newspapers, their names were spelled as Joseph Rister Garka and his wife Rose. In late August, when the gypsies were taken to jail in Freehold, the *Freehold Transcript* reported them as Bristo Jerke and Rosa. At the time the grand jury met in December, Gypsy Joe was reported as Joe Gurgas in the *Asbury Park Press*, and as Joe Jurgas in the *Matawan Journal*. The confusion over the correct spelling of Joe and Rosie's true identity made it difficult to discover where they came from and where they had been.

THE CONFESSION

No matter which spelling you choose, the day after their arrest, Gypsy Joe confessed to killing Max Turnow, and Rosie the Fortune Teller admitted to being Turnow's lover.

Gurgas told Chief McGuire and Monmouth County Detective William Mustoe that a few nights earlier, he went to the fortunetelling shack and found Turnow making love to his wife. McGuire and Mustoe obtained a complete confession from Gurgas. Gurgas told them that in a rage, he seized a butcher knife and slashed Turnow in the back of the neck. Gurgas told police that according to gypsy customs, a man had to buy his wife. Gurgas told them that he paid Rosie's father $5,000 for permission to marry her. That was a very large sum of money in those days.

The fortunetelling shack was located on the pier extending into Raritan Bay and Gurgas told the officers that later that night, he and a friend dumped Turnow's body out the back window of the shack and watched it drop into the bay. Police began the hunt for his accomplice and Officer Joseph Coward of Keyport captured gypsy George Nichols, or Nicholas, the next day in Keyport.

On August 24, police charged all five with murder and moved them to the county jail in Freehold, where Assistant Prosecutor Langdon E. Morris asked that bail be set at $50,000 each. Judge Harry M. Burke went a step further and committed all of them to jail without bail. Attorney Isidore M. Dubrow, a native of Sluzk, Russia, practicing law in Perth Amboy, traveled to Freehold to see if he could get Judge Burke to reduce the bail. Several gypsy tribal chiefs accompanied him to see if they could help get Rosie, the Wallaces and Nichols released. Dubrow promised to secure bail bonds for all the gypsies and agreed to represent Joseph Gurgas. On behalf of his client, Dubrow pleaded innocent due to insanity. A few days later, Dubrow announced to the press that his client would plead not guilty due

to "insanity and the unwritten law." Gurgas remained in jail until the grand jury met in December.

GRAND JURY FAILS TO INDICT

On December 18, the grand jury failed to find an indictment. Why the jury failed to indict, given the killer's confession and the bloody evidence obtained, went strangely unreported. Prosecutor Morris made a motion to dismiss the prisoner and Judge Jacob Steinbach Jr. granted his motion. Gurgas did not have to return to Murderers' Row, an ominous section of the second tier of cells in the county jail. It was the first time in Monmouth County history that four men were held at the same time on separate murder charges. Gurgas left behind accused murderers Joseph Farruggio, Steve Demick and Charles J. Owens. When their cases were heard, Farruggio got thirty years, Demick got thirty years and Owens got life.

As quietly as they moved in, the colorful band of gypsies quietly moved on.

Appendix A

Jurors

State of New Jersey vs. George Lowden, November 12, 1902

Charles E. Thompson
Charles. F. Morris
Ira C. Britton
Lorenzo Mason
Forrest Green
Alonzo White
James F. Edge
Garrett W. Naylor
Harry Brower
William Bray
Edward H. Roberts
William Borden Jr.

State of New Jersey vs. Antonio and Samuel Fernnello (Farinella), November 13, 1917

John Mount of Holmdel
James H. Peters of Long Branch
George L. Quackenbush of Shrewsbury
James Kelsey Jr., of Asbury Park
Henry M. Taylor of Red Bank
William P. Casier of Middletown
Wesley A. Palmateer of Deal
Albert W. Bell of Fair Haven
Jacob Dahl Jr., of Bradley Beach
Ralph B. Sickles of Red Bank
Roy C. James of Asbury Park
J. Elfin Green of Long Branch

State of New Jersey vs. John Vacchano (Vacchiano), May 22, 1922

Louis Gattis
Allen Liming
John V. Long
Frank Hulse
Frank H. Day
Howard Gaffey

Harry Edwards
Jurian S. Lott
Jacob Karr
Joseph Crine
Samuel Keys
Phillip Bonner

State of New Jersey vs. Ralph Icovino (Eovino), January 29, 1923

George Brasck of Highlands
Jacob Rosenfield of Belmar
J. Clark Conover of Red Bank
D. Holmes Ely of Marlboro
Milan Ross Jr. of Allenhurst
Ralph W. Morford of New
Monmouth

David Buck of Freehold
Abraham Post of Keyport
J. Elmer Vanderveer of West
Freehold
William Naylor of Navesink
Robert Wilson of Millstone
Thomas S. King of Belmar

State of New Jersey vs. Mrs. Christina Stoble, April 19, 1927

Earl Snyder of Atlantic Highlands
Joseph G.P. Kennedy of Rumson
Walter J. Sweeney of Sea Bright
William Simmers of Freehold
William V. Statesir of Freehold
George Burdge of Farmingdale

George Rodgers of Navesink
Mrs. Gertrude Scott of Red Bank
William Diggins of Freehold
Ensley M. White of Red Bank
Robert Sturla of Howell
David D. Cashion of Freehold

Appendix B

Monmouth County Murders, 1900–1930

Murders and trials are often overlooked for genealogy research. This list is presented for people researching their ancestral roots in Monmouth County. All names of victims and murderers are included in the index for easy reference. If you are related to a victim or a murderer, there is usually a wealth of information in the public records and newspaper accounts.

During 1910 to 1930, the largest group to migrate to Monmouth County, and many other counties in New Jersey, was the Italians. In 1920, three percent of the population of Monmouth listed their place of birth as Italy. Less than two percent of the people living in Monmouth were Germans, Irish or Russians. These figures may explain why there is a predominance of Italian victims and Italian murderers in this list. Interestingly, most Italian murderers chose Italian victims.

The second largest ethnic group in this list is African Americans. During this time there were three times as many blacks in Monmouth as there were Italians.

By no means is this list limited to Italians or African Americans. It includes people born in other states and other countries as well, including, Austria, Germany and Ireland.

MONMOUTH COUNTY MURDERS 1900–1930

Victim	Accused Murderer	Crime Scene	Year
White, infant	White, Miss Etta	Long Branch	1900
White, infant	White, Mrs. Nellie	Long Branch	1900
White, infant	Fowler, Henry J.	Long Branch	1900
White, infant	Thompson, Dr. Reuben P.	Long Branch	1900
White, William	unknown	Long Branch	1900
Clark, Walter	Toombs, Julius	Ocean	1902
Caine, Robert H.	Lowden, George W.	Avon	1902
unknown infant	unknown	Manasquan	1904
Stratton, Charles	Wasson, George H.	Highlands	1904
Traynum, Rebecca	Brown, Edward W.	Long Branch	1904
Flynn, William J.	Powell, Charles	Long Branch	1904
Baggett, William	Holmes, Alonzo	Freehold	1904
Rozzo, Frank	Lauro, Annelio	Asbury Park	1905
Rozzo, Frank	Scott, Joseph	Asbury Park	1905
Rozzo, Frank	Lauro, Michael	Asbury Park	1905
Walling, Mabel	Walling, Clinton H.	Holmdel	1905
Naftal, Mrs. Mary	Perdoni, Frank	Asbury Park	1905
Naftal, Mrs. Mary	Morris, Frank	Asbury Park	1905
Johnson, Henrietta	Johnson, Samuel	Red Bank	1906
Burch, Cora Lee	Burch, Thaddeus	Long Branch	1906
unknown infant	unknown	Atlantic Highlands	1906
Isaacson, Harry	Straus, Isaac	Asbury Park	1906
Stryker, Catherine	Test, Albert	Keyport	1906
Newson, William	unknown	Spring Lake	1906
Hodges, William	Marchesano, Frank	Asbury Park	1906
Callahan, infant	Callahan, Matilda	Middletown	1907
Callahan, infant	Callahan, Ada	Middletown	1907
Goodrich, infant	Goodrich, Lena	Long Branch	1907
Goodrich, infant	Goodrich, Carrie	Long Branch	1907
Harris, Walter	Claxson, Kate	Asbury Park	1907
Catrambone, Nicholas	Rozzo, Nicholas	Asbury Park	1907
Bane, John	Willis, Charles A.	Long Branch	1908
unknown infant	unknown	Keyport	1908
Bendy, Jennie	Zastera, Frank	Wickatunk	1908

Victim	Accused Murderer	Crime Scene	Year
Sheppard, William	Zastera, Frank	Wickatunk	1908
Sheppard, Josephine	Zastera, Frank	Wickatunk	1908
Reilly, infant	Reilly, Mary	Shrewsbury	1908
Villepiano, Michael	Crispo, Gavino	Asbury Park	1909
Livadotte, Thomas	Catalino, John	Long Branch	1909
Livingston, David	Mountjoy, Robert	Eatontown	1910
McCabe, John Hugh	Walling, Allen	Keyport	1910
Smith, Marie	Heidemann, Frank	Asbury Park	1910
Pulley, Rebecca	Pulley, Henry	Long Branch	1911
Brady, Patrick	Lucia, Joseph	Long Branch	1911
Truglia, Rocco	Cropella, Rocco	Long Branch	1911
Lippincott, Charles F.	Clayton, Charles D.	Asbury Park	1911
Baulthwright, Ethela	Murray, Florence	Asbury Park	1912
Chiriano, Salvatore	Chiriano, Joseph	Long Branch	1912
Alffano, Joseph	Vetrano, Nicholas	Asbury Park	1912
Alffano, Joseph	Ferraro, Thomas	Asbury Park	1912
Ponessa, Maria Agnes	Ponessa, Joseph	Long Branch	1912
Boyce, Mary	Evans, George W.	Sea Bright	1912
Ceppalunio, Alfred	Ceppalunio, Sebastian	Long Branch	1912
Shebell, Genario	Torino, Biaggio	Asbury Park	1913
Brown, William	Reevey, Alphonso	Fair Haven	1913
Green, Belle	Boone, Jeanette	Asbury Park	1913
Harris, George K.	unknown	Sea Girt	1913
Arena, Guiseppe	unknown	Asbury Park	1913
Gaskin, Fred	Clayton, Charles T.	Belmar	1913
unknown	Kelly, William K.		1914
Reeves, Jr., Alfred	Salm, Ernest	Red Bank	1914
Cranfield, William	O'Leary, Morgan J.	Howell	1914
Ely, Charles A.	Sparks, Richard P.	Freehold	1914
Ely, Charles A.	Green, George	Freehold	1914
Lopresto, John	unknown	Red Bank	1914
Sherlock, John	Stachano, Eddie	Holmdel	1914
Lagana, Pasquale	Crapella, Joseph	Long Branch	1914
Lagana, Pasquale	Martello, Rocco	Long Branch	1914
Bagnato, Dominic	Gulla, Salvatore	Long Branch	1915
Bagnato, Dominic	Rossano, Antonio	Long Branch	1915
Bagnato, Dominic	Natora, Pietro	Long Branch	1915
Aker, Jane	Swentain, Emil	Farmingdale	1915

Victim	Accused Murderer	Crime Scene	Year
Arnone, Frank	Galatro, John	Red Bank	1915
Granato, Pasquale	Romaino, Joseph	Middletown	1915
Carascalina, Servia	Vona, Theodore	Long Branch	1915
unknown	Haynes, George Hulbert		1916
unknown	Johnson, Clinton William		1916
unknown	Muller, Raymond Charles		1916
unknown	Grant, Jennie B.		1916
unknown	Garrity, James C.		1916
Boston, Sr., John	Swentain, Emil	Farmingdale	1916
Bass, Charles	Hawkins, James	Long Branch	1916
Lillis, William H.	Carhart, Harry	Deal Lake	1916
Lasalle, Joseph	Vona, Louis	West Grove	1916
Lasalle, Joseph	Santinello, Frank	West Grove	1916
Lasalle, Joseph	Conte, John	West Grove	1916
Hodges, Emma R.	Hodges, Frank	Red Bank	1916
Weber, Frank	Russo, Anthony	Raritan	1916
Nolan, Sr., Mrs. Katie	Forman, Harry	Millhurst	1916
Johnson, Milton	McCauldin, Helen	Little Silver	1916
unknown	Woolman, F. Albert		1917
Casale, James	Farinella, Antonio	Freehold	1917
Casale, James	Farinella, Samuel	Freehold	1917
Mosley, John	Alexander, William	Freehold	1917
Morris, Frank	Day, William	Long Branch	1917
unknown	Brown, John E.		1918
Mazza, Guiseppe	Petraglia, Peter	Atlantic	1919
Warzinger, Israel	Besela, Louis	Raritan	1919
Caruso, Sophia	Besela, Louis	Raritan	1919
Crispo, Nunzio	Vacchiano, John	Asbury Park	1919
Burke, Mary J.	Boulin, Jean J.	Avon	1920
Vaughn, Elmer	Martin, Fred	Asbury Park	1920
Arthur, Chester	Aborde, Salvadore	Allenhurst	1921
Young, Charles	Morris, Joseph	Asbury Park	1921
Gisvanello, Donato	Siciliano, Patsy	Asbury Park	1921
Gallagher, Dennis	Gallagher, Viola	Highlands	1921
Caizzo, Carmen	Cierao, Salvatore	Neptune City	1921
Caizzo, Carmen	Fontana, Bartholemew	Neptune City	1921
Maccanico, Camela	Picone, Arico	Neptune	1921
Washington, George	Grant, John	Matawan	1921

Victim	Accused Murderer	Crime Scene	Year
Reevey, Nelly	Reevey, Lee Grant	Eatontown	1921
unknown	Wainwright, Samuel		1922
Santaniello, Salvatore	unknown	Little Silver	1922
Wessels, Gesine	Renzelman, Mrs. Helmina	Eatontown	1922
Voelke, John	Voelke, Ethel	Ocean	1922
Voelke, John	Worth, Ernest	Ocean	1922
Vittoria, Charles	Torre, Samuel	Keansburg	1922
Albe, William	Stafford, James	Middletown	1922
Alderello, Ralph	Quatrano, James	Asbury Park	1922
Wagner, Michael F.	Reed, William H.	Shrewsbury	1922
Brannagan, John	Kaminski, Stanley	Belmar	1922
Eovino, Amelia	Eovino, Ralph	Holmdel	1922
Jackson, Richard	Ogette, Raymond	Keyport	1922
Shendalis, Charles	Pappas, Charles	Fair Haven	1922
Underwood, Isaac	Cass, William Gordon	West Long Branch	1922
Holmes, Russell	Johnson, William	Little Silver	1923
Carter, Thomas H.	Tedesco, Nunzio	Long Branch	1923
Hubbard, William	Hubbard, Caleb	Belmar	1923
Hubbard, William	Forman, Herbert	Belmar	1923
Spindler, Charles	Hubbard, Caleb	Belmar	1923
Spindler, Charles	Forman, Herbert	Belmar	1923
Peters, Joseph E.	King, Wilbur	Ocean	1923
Bly, Hannah	Santora, Andrew R.	Shrewsbury	1923
Capalloppo, Ralph	Tomaino, William	Eatontown	1924
Davis, Bertha	Davis, William	Red Bank	1924
Dunsky, Isidore	unknown	Sandy Hook	1925
Richards, Jennie	Richards, George	Atlantic	1925
Gronan, John A.	Zeiser, Edward E.	Asbury Park	1925
Marzante, Phillip	DeBell, James	Keansburg	1925
DiAngelo, Dominick	Amaturo, Pietro	Holmdel	1925
Nicolini, Marie	Siciliano, Teresa	Asbury Park	1925
Eberle, Leigh	Hall, David	Middletown	1925
Hill, Patrick	Mills, Owen	Asbury Park	1925
Usterman, Lance	Petillo, Patsy	Asbury Park	1925
Usterman, Lance	Vona, Theodore	Asbury Park	1925
McKeon, Patrick	unknown	Eatontown	1925
Shaw, Robert	Williams, Mancey	Asbury Park	1926
Harris, Lena	Johnson, John A.	Middletown	1927

Victim	Accused Murderer	Crime Scene	Year
Boggs, Edward A.	Craig, Donald H.	Long Branch	1927
Stoble, Rosina	Stoble, Christina	Red Bank	1927
Tice, Norman	Patterson, Charles C.	Holmdel	1927
Carney, Osborn	Owens, Charles J.	Asbury Park	1927
Meisterknecht, Hebert O.	Schreiber, Alexander	Highlands	1927
Katz, Mollie	Schiller, Isaac	Freehold	1928
Evenanko, Nikita	Demick, Steve	Freehold	1928
Turnow, Max	Gurgas, "Gypsy Joe"	Keansburg	1928
Morris, Grace	Welsh, Raymond	Red Bank	1928
Johnson, Harold	Farruggio, John	Neptune	1928
Kelly, Andrew	Hughes, Myrtle	Middletown	1928
Brown, George W.	Moulton, Herbert	Middletown	1928
Sheridan, Edward	Ross, Jr., Pierre Sanford	Sea Bright	1929
Roberts, Mrs. Menia	Lane, Mrs. Ora	Red Bank	1929
Green, Olivia	Crummal, Amos	Red Bank	1929
Wright, Sylvia	Mazzocchi, Frank	Middletown	1929
Williams, Edward	Reevey, Harold	Red Bank	1929
Danielson, George	McBrien, John	Bradley Beach	1929
Danielson, George	Sargent, James	Bradley Beach	1929
Danielson, George	Long, Francis	Bradley Beach	1929
Danielson, George	Tully, Robert	Bradley Beach	1929
Salamone, Anthony	DiDonato, Vito	Atlantic	1929
Copeland, Noah	West, Robert	Asbury Park	1929
Celeste, Gertrude	Crummal, Amos	Middletown	1929
Hart, Agnes	Lacke, James	Raritan	1929
Pittenger, Jacob L.	McCall, Richard	Freehold	1929
Pittenger, Jacob L.	Ward, Bernard A.	Freehold	1929
Goode, Henry	Bowles, Alonzo	Red Bank	1929
unknown	Turner, Andrew G.	Manalapan	1929
Williams, Grace	Wyant, Arthur	West Long	1929
Prather, Maggie	Wilson, David	Belmar	1929
unknown	Baxter, Russell		1930
Waddle, Raymond	Bailey, Robert	Highlands	1930
Waddle, Raymond	Bailey, John	Highlands	1930
Waddle, Raymond	Parker, Lewis	Highlands	1930
Waddle, Raymond	West, Robert	Highlands	1930
Oriente, Salvatore	unknown	Asbury Park	1930
Gibbs, Prenzia	Phillips, Charles	Asbury Park	1930

Bibliography

CHAPTER 1: WHITE MURDER, MAY 1900

Asbury Park Press, "Dr. Prefers Jail Life to a Parole," January 23, 1909.

Asbury Park Press, "No Pardon for County Convicts," July 19, 1906.

Asbury Park Press, "Thompson and Fowler Get Heavy Sentences," January 2, 1901.

Baltimore Sun, "Confesses to Murder," July 6, 1900.

Long Branch Daily Record, "Fowler Arrested on a Serious Charge," July 6, 1900.

Long Branch Daily Record, "Grand Jury Finds 14 Indictments," October, 26, 1900.

Long Branch Daily Record, "Held in $800 Bail," June 29, 1900.

Long Branch Daily Record, "No Evidence to Convict," January 25, 1901.

Long Branch Daily Record, "Paroled Prisoner Won't Leave Prison," January 25, 1909.

Long Branch Daily Record, "Still in Freehold Jail," January 11, 1901.

Long Branch Daily Record, "White-Fowler Case with Grand Jury," October, 5, 1900.

Long Branch Daily Record, "White Women to Be Sentenced Monday," January 18, 1901.

Matawan Journal, "Fowler and Thompson," January 3, 1901.

Matawan Journal, "Murderer Wants Clemency," June 14, 1906.

Monmouth County Archives, Coroner's Inquest, July 4, 1900.

New Jersey Archives, Death Certificate, son of Etta White, May 1, 1900.

New Jersey Archives, New Jersey State Prison Records, Descriptive List of Convicts.

New York Times, "Child Killers Sentenced," January 3, 1901.

Red Bank Register, "Long Terms in Prison," January 9, 1901.

Trenton Evening Times, "Doctor Convict Refuses Parole," January 22, 1909.

Trenton Evening Times, "Thompson Refuses to Leave Jail," January 23, 1909.

CHAPTER 2: CAINE MURDER, AUGUST 1902

Asbury Park Press, "Funeral of Murdered Man," August 26, 1902.

Asbury Park Press, "Kain's Injuries Result Fatally," August 25, 1902.

Asbury Park Press, "Lowden Testifies in Murder Case," November 14, 1902.

Asbury Park Press, "Murder Trial Is on at Freehold," November 13, 1902.

Asbury Park Press, "Negro Murderer Gets 20 Years," January 6, 1903.

Monmouth County Archives, Coroner's Inquest, Robert Caine, August 30, 1902.

Monmouth County Archives, Murder Indictment, State vs. George Lowden, November 12, 1902.

New Jersey Archives, Death Certificate, George Lowden, July 12, 1911.

New Jersey Archives, Death Certificate, Robert H. Caine, August 23, 1902.

New York Times, "Non Vult Plea in Lowden Murder Case," November 14, 1902.

Red Bank Register, "Slashed with a Razor," August 27, 1902.

CHAPTER 3: TRAYNUM MURDER, JUNE 1904

Asbury Park Press, "Brown on Stand in Own Defense," May 22, 1906.

Asbury Park Press, "Brown Sentenced Today by Justice Hendrickson," May 28, 1906.

Asbury Park Press, "First Degree Verdict Found Against Brown," May 23, 1906.

Asbury Park Press, "Lawyers Object to Defending Negro," May 1, 1906.

Asbury Park Press, "Murderer Uncaptured," June 13, 1904.

Asbury Park Press, "Wife Murderer Gets 20-Year Sentence," May 21, 1906.

Freehold Transcript, "Brown Hung This Morning," June 29, 1906.

Long Branch Daily Record, "Accused Murderer in Freehold Jail," April 27, 1906.

Long Branch Daily Record, "Brown Baptized Today," June 28, 1906.

Long Branch Daily Record, "E.W. Brown, Alleged Slayer of Girl Here Now in Freehold Jail," April 23, 1906.

Long Branch Daily Record, "Girl Shot and Instantly Killed," June 17, 1904.

Long Branch Daily Record, "Lawyers Shy of Defending Brown," May 1, 1906.

Long Branch Daily Record, "Murderer Brown Caught in Chicago," April 21, 1906.

New Jersey Archives, Death Certificate, Rebecca Traynum, June 11, 1904.

New York Times, "Baptized in a Bathtub," June 30, 1906.

Red Bank Register, "Edward Brown Hanged," July 4, 1906.

Red Bank Register, "Murder at Long Branch," June 15, 1904.

Red Bank Register, "Murderer to Be Hung," May 30, 1906.

CHAPTER 4: SHEPPARD/BENDY MURDER, MAY 1908

Asbury Park Press, "Boy Farmhand Confesses Triple Wickatunk Murder," May 18, 1908.

Asbury Park Press, "Murder Trial Goes Off Until Sept. 21," July 27, 1908.

Asbury Park Press, "Russian Farmhand, Discharged, Murders Three at Wickatunk," May 16, 1908.

Asbury Park Press, "Take Murderer to the Scene of His Crime," May 19, 1908.

Asbury Park Press, "Zastera, Held to Be Insane, Is Sent to State Asylum," September 21, 1908.

Asbury Park Press, "Zastera Now Denies He Killed Sheppard, His Wife and Servant," May 20, 1908.

Freehold Transcript, "Confession Can Be Used," May 29, 1908.

Freehold Transcript, "Murder Trial July 27," June 11, 1908.

Freehold Transcript, "Murder Trial Postponed," July 31, 1908.

Freehold Transcript, "Murder Trial Soon," June 5, 1908.

Freehold Transcript, "Murderer Goes to Asylum," September 25, 1908.

Freehold Transcript, "Three Persons Murdered," May 22, 1908.

Long Branch Daily Record, "Murderer Plays Violin in Prison," June 15, 1908.

Matawan Journal, "Judge Hoffman Declares Treatment of Zastera an Outrage," May 28, 1908.

Matawan Journal, "Three Murdered at Wickatunk," May 21, 1908.

Monmouth County Archives, Coroner's Inquest, Sheppard, Sheppard, Bendy, June 6, 1908.

New Jersey Archives, Death Certificate, Josephine R. Sheppard, May 16, 1908.

New Jersey Archives, Death Certificate, William B. Sheppard, May 16, 1908.

New York Times, "Bible Used to Get Slayer's Confession," May 19, 1908.

New York Times, "Farm Hand Killed Sheppards, They Say," May 18, 1908.

New York Times, "Held for Farm Murders," June 7, 1908.

New York Times, "Man, Wife and Maid Murdered on Farm," May 17, 1908.

New York Times, "To Try Zastera To-Day," September 21, 1908.

New York Times, "Zastera Sent to Madhouse," September 22, 1908.

Newark Evening News, "Insane Asylum for Murderer," September 21, 1908.

Red Bank Register, "Sheppard and Bendy Obituaries," May 20, 1908.

Trenton Evening Times, "Robbery Motive of the Triple Murder," May 18, 1908.

Trenton Evening Times, "Zastera Again Confesses Murder," May 19, 1908.

Trenton Evening Times, "Zastera Committed to Trenton State Hospital," September 23, 1908.

Trenton Evening Times, "Zastera on Trial for Triple Murder," September 21, 1908.

Trenton Evening Times, "Zastera on Trial, Pleads Insanity," July 27, 1908.

Trenton Evening Times, "Zastera Says Not Guilty," June 12, 1908.

Trenton Evening Times, "Zastera Trial Postponed," July 28, 1908.

CHAPTER 5: HARRIS MURDER, JULY 1913

Asbury Park Press, "Believe Harris at Sea Girt May Never Be Solved," July 1, 1913.

Asbury Park Press, "Bullet Riddled Body Is Found at Sea Girt," July 29, 1913.

Asbury Park Press, "Claiming Harris Ended Own Life, Detective Quits," August 4, 1913.

Asbury Park Press, "Inquest in the Sea Girt Slaying Set for Tuesday," July 30, 1913.

Asbury Park Press, "No New Murder Clues Disclosed in Coroner's Inquest," August 5, 1913.

Asbury Park Press, "Slain Man Not One She Sought," August 8, 1913.

Freehold Transcript, "Man Killed at Sea Girt," August 1, 1913.

Freehold Transcript, "Sea Girt Murder," August 8, 1913.

Jersey Journal, "4th Regt. Men Implicated in Murder Case," August 4, 1913.

Jersey Journal, "Company K Man Is Implicated in Murder Mystery," August 4, 1913.

Jersey Journal, "A Murder Mystery at State Camp," July 29, 1913.

Jersey Journal, "Murder Mystery Near Sea Girt Camp Is Still Unsolved," July 30, 1913.

Jersey Journal, "Sea Girt Murder Victim Was a Gambler," July 31, 1913.

Long Branch Daily Record, "Minugh Drops Sea Girt Case," August 5, 1913.

Long Branch Daily Record, "Suspect Stranger in Sea Girt Case," August 6, 1913.

New York Times, "Shot Near Fielder Home," July 30, 1913.

Trenton Evening Times, "Harris Murdered, Inquest Verdict," August 6, 1913.

Trenton Evening Times, "Looks Like Murder Near Fielder's Home," July 29, 1913.

Chapter 6: Casale Murder, August 1917

Asbury Park Press, "Accused Men Give Lie to Witnesses," November 15, 1917.

Asbury Park Press, "Gasoline Can Used by Slayers Is Found Buried," August 20, 1917.

Asbury Park Press, "Huckster Shot, Body Oil Soaked and Set Afire," August 18, 1917.

Asbury Park Press, "Life Sentences Are Imposed Upon Casale's Slayers," November 16, 1917.

Asbury Park Press, "Murder Case Will Go to Jury Today," November 14, 1917.

Asbury Park Press, "Murder Trial Is on at Freehold," November 13, 1917.

Freehold Transcript, "Farinella Brothers Tried for Murder," November 16, 1917.

Freehold Transcript, "Murder at Old Bridge," April 27, 1917.

Freehold Transcript, "Murder Near Freehold Two Brothers Accused," August 24, 1917.

Freehold Transcript, "Murderers in Prison," November 23, 1917.

Home News, "Finding Gun Helps Solve Two Murders," August 24, 1917.

Matawan Journal, "Murder at Old Bridge," May 3, 1917.

Matawan Journal, "Old Bridge Huckster Killed," August 23, 1917.

Monmouth Democrat, "Huckster Murdered," August 23, 1917.

New Jersey Archives, Death Certificate, Gandollo Farinella, April 24, 1917.

New Jersey Archives, New Jersey State Prison Records, Descriptive List of Convicts.

New Jersey Archives, New Jersey State Prison Records, Prisoner Register.
New York Times, "Slay Man in Jersey Woods," August 18, 1917.
Newark Evening News, "New Clue Sought to Casale Killing," August 18, 1917.

CHAPTER 7: CRISPO MURDER, JULY 1919

Asbury Park Press, "Confessed Slayer of Local Italian Now in Freehold," March 18, 1922.
Asbury Park Press, "Confessing Murder, Gets Life Sentence—Vacchiano Pleads Not Guilty," March 22, 1922.
Asbury Park Press, "Declares He Shot in Self Defense," May 23, 1922.
Asbury Park Press, "Funeral of Murdered Man," July 23, 1919.
Asbury Park Press, "Italian Feud Results in Springwood Murder," July 21, 1919.
Asbury Park Press, "Local Parolee Held in Knifing of Sweetheart," March 3, 1941.
Asbury Park Press, "Local Slayer, Taken in Milwaukee, Admits Guilt," March 8, 1922.
Asbury Park Press, "Say Crispo Murderer Is Hiding in City," July 22, 1919.
Asbury Park Press, "Vacchiano Guilty Verdict of Jury," May 24, 1922.
Asbury Park Press, "Vacchiano Sent Back to Prison," March 4, 1941.
Milwaukee Journal, "New Jersey to Send for Alleged Slayer," March 8, 1922.
Milwaukee Sentinel, "City Worker Is Held for New Jersey Slaying," March 8, 1922.
New Jersey Archives, Death Certificate, Nunzio Crispo, July 21, 1919.
New Jersey Archives, New Jersey State Prison Records, Descriptive List of Convicts.
New Jersey Archives, New Jersey State Prison Records, Prisoner Register.
Red Bank Register, "Murderer Captured," March 15, 1922.

CHAPTER 8: VAUGHN MURDER, SEPTEMBER 1920

Asbury Park Press, "Seek Missing Negro as Possible Slayer," September 15, 1920.
Asbury Park Press, "Slain by Knife Thrust in Altercation with Negro," September 14, 1920.
Asbury Park Press, "Vaughn Slayer Captured; Admits Fatal Stabbing," March 19, 1921.

Asbury Park Press, "Vaughn Slayer Gets Six to Thirty Years," May 25, 1921.

Asbury Park Press, "Vaughn Slayer Still at Large," September 16, 1920.

Freehold Transcript, "Murder at Asbury," September 17, 1920.

Freehold Transcript, "Murderer Caught," March 25, 1921.

Freehold Transcript, "Sentence of Six Years for Killing," May 27, 1921.

New Jersey Archives, Death Certificate, Elmer S. Vaughn, September 14, 1920.

New Jersey Archives, Death Certificate, Lauretta Vaughn, January 24, 1923.

New Jersey Archives, New Jersey State Prison Records, Descriptive List of Convicts.

CHAPTER 9: MACCANICO MURDER, AUGUST 1921

Asbury Park Press, "Believe Slayer May Yet Commit Suicide," August 6, 1921.

Asbury Park Press, "Funeral of Slayer," August 12, 1921.

Asbury Park Press, "Girl Slain on Wedding Eve by Rejected Suitor," August 4, 1921.

Asbury Park Press, "Murderer Kills Self on Spot Where He Slew Girl," August 10, 1921.

Asbury Park Press, "Officials Hold Picone a Suicide; Body Sent Home," August 11, 1921.

Asbury Park Press, "Shot Girl to Save Her from Union She Hated, Says Suicide," August 15, 1921.

Asbury Park Press, "Slain Girl Is Buried in Her Bridal Attire," August 5, 1921.

New Jersey Archives, Death Certificate, Arico Picone, August 10, 1921.

New Jersey Archives, Death Certificate, Camela Maccanico, August 3, 1921.

New York Times, "Diary Tells of Murder," August 16, 1921.

New York Times, "Vendetta Claims Girl Slayer's Life," August 11, 1921.

Newark Evening News, "Girl Slain as Day of Wedding Nears," August 4, 1921.

Trenton Evening Times, "Killed Cousin to Save Her Sorrow," August 15, 1921.

Trenton Evening Times, "Man's Body Is Found in Room Where He Killed Girl," August 10, 1921.

Trenton Evening Times, "Mystery in Death at Shore," August 10, 1921.

Trenton Evening Times, "Refused by Cousin, Kills Her, Escapes," August 4, 1921.

Chapter 10: Eovino Murder, August 1922

Asbury Park Press, "Continue Trial of Alleged Murderer," January 30, 1923.

Asbury Park Press, "Shoots at Lover But Kills Wife," August 9, 1922.

Asbury Park Press, "Told to Convict Wife Slayer, Jury Bestows Freedom," January 31, 1923.

Freehold Transcript, "Farmer Shot Wife," August 11, 1922.

Freehold Transcript, "Unwritten Law Prevails Here," February 2, 1923.

Long Branch Daily Record, "Eovino Acquitted of Killing Wife," January 31, 1923.

Long Branch Daily Record, "On Trial for Killing His Wife, Eovino Says He Shot in Self-Defense," January 30, 1923.

Matawan Journal, "Tried for Killing His Wife, Eovanio Goes Free," February 2, 1923.

New Jersey Archives, Death Certificate, Amelia Icovino (Eovino), August 8, 1922.

New York Times, "Defy Court, Free Slayer," January 31, 1923.

Red Bank Register, "Farmer Kills His Wife," August 9, 1922.

Chapter 11: Stoble Murder, March 1927

Asbury Park Press, "'An Awful Dream' Says Mother Who Shot Child," March 8, 1927.

Asbury Park Press, "Guilty of Manslaughter, Mrs. Stoble Gets 10 Years," April 22, 1927.

Asbury Park Press, "Jury for Stoble Murder Trial Is Quickly Drawn," April 19, 1927.

Asbury Park Press, "Mentally Irresponsible, Mrs. Stoble's Defense," April 20, 1927.

Asbury Park Press, "Mother Slays Daughter Beside Newborn Babe," March 7, 1927.

Asbury Park Press, "Quinn Recommends Life; Execution 'Too Good,'" April 21, 1927.

Freehold Transcript, "Mrs. Stoble Begins Ten Year Sentence," April 29, 1927.

Freehold Transcript, "Stoble Murder Trial Here Attracts Much Attention," April 22, 1927.

Long Branch Daily Record, "Jury Selected to Try Woman for Slaying Her 16-Year-Old Daughter," April 19, 1927.

Long Branch Daily Record, "Mrs. Stoble on Stand Tells Her Own Story of Ghastly Crime," April 20, 1927.

New Jersey Archives, Death Certificate, baby Stoble, March 6, 1927.
New Jersey Archives, Death Certificate, Rosina Stoble, March 7, 1927.
New York Times, "Kills Daughter, an Unwed Mother," March 8, 1927.
New York Times, "Mrs. Stoble Indicted," March 17, 1927.
New York Times, "Mrs. Stoble Testifies in Her Own Behalf," April 21, 1927.
New York Times, "Mrs. Stoble, Slayer of Daughter, Guilty," April 23, 1927.
New York Times, "Mrs. Stoble's Fate Weighed by Jurors," April 22, 1927.
New York Times, "Says Woman Slayer Is Sane," April 19, 1927.
New York Times, "Slain Girl Buried Near Child," March 9, 1927.
New York Times, "Woman Slayer to Plead Insanity," April 17, 1927.
Red Bank Register, "Killed Her Daughter," March 9, 1927.
Red Bank Register, "On Trial for Her Life," April 20, 1927.

Chapter 12: Turnow Murder, August 1928

Asbury Park Press, "Four Gypsies Held as Witnesses in Murder," August 22, 1928.
Asbury Park Press, "Gypsy Charged with Murder," August 24, 1928.
Asbury Park Press, "'Gypsy Joe' Freed in Murder Case," December 19, 1928.
Asbury Park Press, "Killed Man He Found Loving Fortune Teller," August 23, 1928.
Asbury Park Press, "Murdered Body Found Off Shore," August 16, 1928.
Asbury Park Press, "Turnow Murder Is Lacking Clues," August 17, 1928.
Daily Home News, "Jealousy Over $5,000 Wife Alleged Cause for Slaying," August 23, 1928.
Freehold Transcript, "Gypsies Held in Murder Mystery," August 24, 1928.
Keyport Weekly, "Believe Man Murdered," August 17, 1928.
Keyport Weekly, "Gypsies Held in Nutley Man's Death," August 24, 1928.
Keyport Weekly, "Insanity and the Unwritten Law," August 31, 1928.
Keyport Weekly, "Unable to Connect Gypsy with Murder," December 21, 1928.
Matawan Journal, "Insanity and the Unwritten Law," August 31, 1928.
Matawan Journal, "Unable to Connect Gypsy with Murder," December 21, 1928.
New Jersey Archives, Death Certificate, Max Turnow, August 13, 1928.
New York Times, "Gypsies Held in Murder," August 23, 1928.
New York Times, "Say Gypsy Admits Killing," August 24, 1928.
Newark Evening News, "Gipsies Held in Man's Death," August 22, 1928.
Newark Evening News, "Gipsy Admits Shore Slaying," August 23, 1928.

Newark Evening News, "Nutley Man Believed Slain," August 16, 1928.

Nutley Sun, "Jealous Gypsy Is Said to Have Confessed to Murder of Max Turnow," August 24, 1928.

Nutley Sun, "Knife Victim's Funeral Is Held at Rutherford," August 17, 1928.

Red Bank Register, "Murder at Keansburg," August 29, 1928.

Index

Index

Y

Z

Courtesy of Sam Joyner.

About the Author

George Joynson, MBA, lives in Monmouth County with his wife and son. He is a professional genealogy researcher with twenty years' experience and offers his research skills to others seeking help discovering their ancestral roots through www.gjoynson.com. Joynson can easily be reached at gj@gjoynson.com.

Please visit us at
www.historypress.net